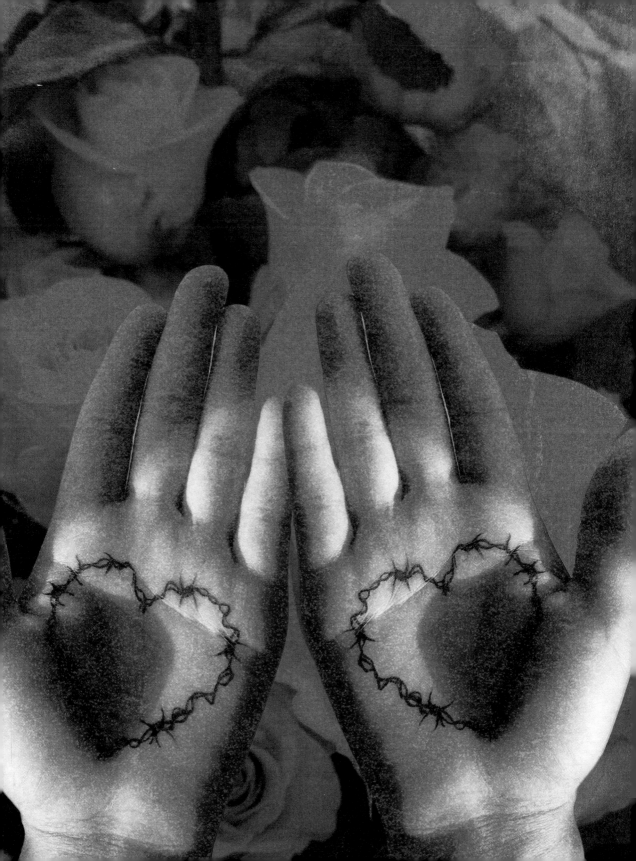

BLOOD SEX MAGIC

EVERYDAY MAGIC FOR THE MODERN MYSTIC

HarperONE
An Imprint of HarperCollinsPublishers

SEX

MAGIC

BLOOD

Bri Luna

CREATOR OF THE HOODWITCH

MAGIC

BLOOD

SEX

BLOOD SEX MAGIC. Copyright © 2023 by Bri Luna. All rights reserved. Printed in the United States of America. No part of this book may be used or reproduced in any manner whatsoever without written permission except in the case of brief quotations embodied in critical articles and reviews. For information, address HarperCollins Publishers, 195 Broadway, New York, NY 10007.

HarperCollins books may be purchased for educational, business, or sales promotional use. For information, please email the Special Markets Department at SPsales@harpercollins.com.

FIRST EDITION

Designed by Janet Evans-Scanlon

Library of Congress Cataloging-in-Publication Data is available upon request.

ISBN 978-0-06-308145-1

23 24 25 26 27 LBC 5 4 3 2 1

CONTENTS

I AM MY SISTER'S KEEPER

The witch, bruja, healer, mother, sister, daughter, lover, artist, creative, bitch, wild woman, visionary, goddess. Transcendent of time and space. Reclaiming power and ancestral bloodlines of magic from the heavens and the earth. I come from dirt and blood, jewels and bones, moon and sun.
I am my grandmothers' secrets, hopes, and dreams. I adorn myself in light and shadows. But do not mistake my flesh nor my worldly appearance for vanity, for everything I do is deliberate. I walk in gratitude for the ones who've come before me. My vessel is ancient. This skin remembers being birthed through the cosmos and rising out of the depths of the sea. Do not mistake her softness, vulnerability, sensitivity, compassion, love, resilience, or silence for weakness. I am birthed of fire and lava, of death and decay.
A huntress, a warrior, not a worrier.
I am my sister's keeper.

—B. Luna

INTRODUCTION

MEANINGFUL RITUALS

I t was such an extraordinary challenge to choose what to include in this book and why, and all of that struggle ended up in these pages. My stories are meaningful to me, and they're meaningful to my family and to our special type of magic and the magic that I've created in my life. Sometimes those magical experiences are like a series of unfortunate events, and other times they are opportunities that I never believed were possible for me, that I never even dreamed of. Or maybe I have dreamed of them.

I have always loved books. I have always loved reading. When I was a child, sitting with my grandma Sylvia at her breakfast table, we would read the *Weekly World News*, a little tabloid in black and white. And I would see headlines like "Bat Boy" and really weird stories about carnival freaks. My grandma loved these very bizarre papers and believed in them. She loved UFO stories. She loved ghost stories. My love for the strange and mystical parts of life stemmed from these early moments reading with her at the small table in her kitchen. As I grew older, I became fascinated with storytelling, tapping into the deeper collective consciousness of human beings to share experiences across cultures. I've gotten lost in books and created my own worlds, using my imagination.

In writing this book, I wanted to create something that would be special—for me and for my readers. I wanted something that I knew was authentic and real to my culture, to my history, and to my family. So I offer you in this book a glimpse into magic as I have come to know it—in bursts of emotion, experience, and passion. It starts with my ancestors (Part One: Blood); next, the divine feminine (Part Two: Sex); and finally, rituals and practices (Part Three: Magic). There are lessons, stories, spells, and warnings. They are powerful because they are true. But these stories are not linear. There is no beginning and no end.

Hopefully, this book will resonate with those who can understand my story and my upbringing, who have a passion for developing their powers and their intuition in their day-to-day life. You know—those who are dealing with anxiety, dealing with stress, dealing with family, and still finding time to create meaningful rituals.

If you take one thing from this book, I hope it is this: Magic doesn't always have to be some big, elaborate ritual. Sometimes magic is as simple as lighting a candle and saying a manifestation, taking a warm salt bath, slowing down and being present with your innermost self, or creating a meaningful ritual for this moment. When you feel like you are simply trying to survive another day, performing meaningful rituals can feel like pulling yourself out of the depths of hell. That is where the power of transformation can be found.

My intention with this book is to share my stories and practical rituals to empower you. If you get something out of it, wonderful. If you don't, fuck it—this isn't for everybody. Which is what makes it special.

Take what you need and leave the rest behind.

BLOOD

DO YOU REMEMBER
WHO YOU ARE?

Have you lost your way? Do you remember your power? Should I remind you? Do you remember that you are the only magic you need?

Do not allow anyone to define you. Your magic is what the fuck you say it is.

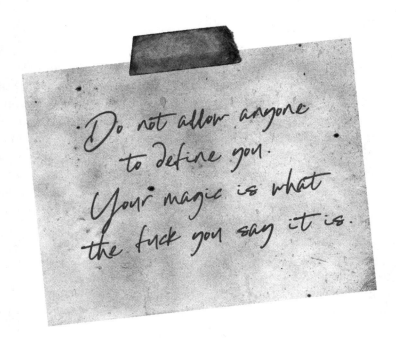

BECOMING

A witch is not something that you become. It is who you are and what you have always been. I identify as a witch in this lifetime and the multitude of lives before this time.

The witch embodies autonomy over self and soul. The witch is rebellion. The freedom to be your most authentic self. To embrace all aspects of whoever that may be.

I have never needed to call my magic by a name; it is a little bit of this and a little bit of that, like me. I infuse elements of both my cultures, and I utilize every aspect of traditional folk healing from my Indigenous Mexican and African American ancestors. I have learned and implemented rituals from witches and healers in my own family and from those I've met along my journey. I trust my intuition and let it guide me. I study plants and minerals for their healing properties. I use color, astrology, candles, and oils.

There is no differentiation in my world between the mundane and the mystical—they coexist together. My creative process is extreme, just as nature is extreme. My intentions are powerful, and in my creative rituals I dedicate myself completely to the desired outcome.

At this time, there is a strong yet subtle shift taking place on our planet. Witches, especially witches of color, are reclaiming their personal power, and that scares people. This energy has been inside us for many, many years. It is an ancient wisdom suppressed by societal conditioning and pressures to conform. Many young women have been taught to ignore or discredit their intuition, or what some might call psychic senses, for fear of being called crazy or facing ridicule from friends and family. Eventually we lose the connection to living with the cycles of nature and, sadly, ourselves.

Magic is our birthright. The witch prevails from now until eternity because the witch shape-shifts with cycle and season. The witch transcends time and space, and survives in the heart and mind of anyone who wishes to shed their soul like a serpent.

The witch lives because the witch has never died.

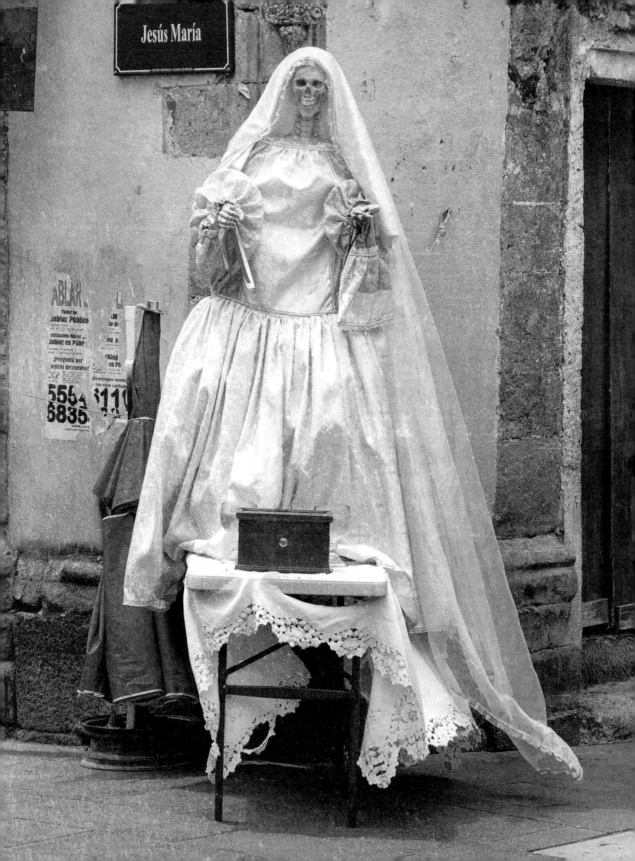

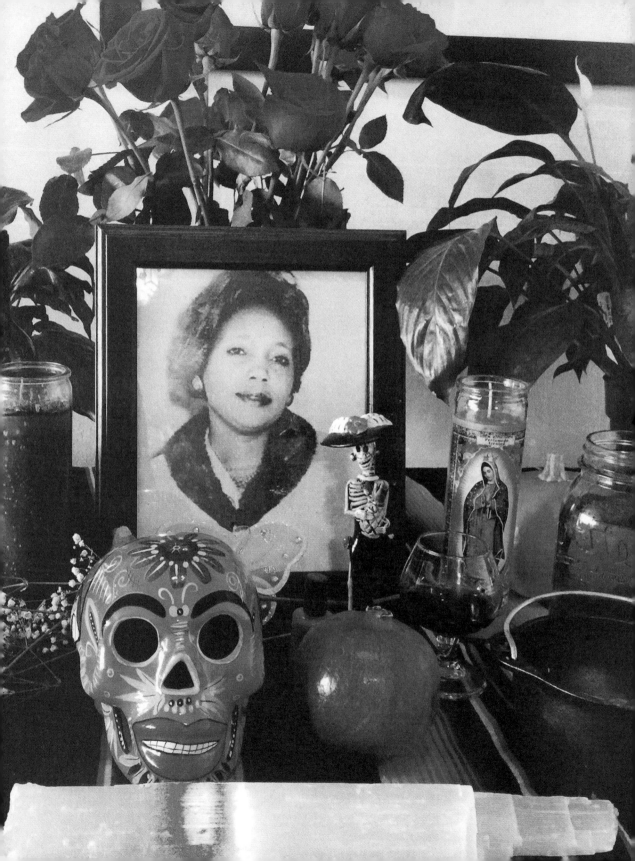

ANCESTRAL PRAYER

I was woken by spirit to give thanks for my ancestors who sacrificed their lives for me to be here today.

Thank you for everything you have done for our families and for your resilience, as you lived through experiences you shouldn't have had to endure.

Thank you for the powerful blood that runs through my veins as a reminder of my connection to our land.

Although they tried stripping us from each other, removing our languages, names, and history, our magic never died, our love never died, our strength never died.

I love you, ancestors.

Thank you for your love and protection; your medicine heals me and gives me the encouragement to keep my head held high.

May your souls be at peace knowing that we will continue to fight for you; we will heal our families of these generational curses; we will awaken and give thanks in order to honor you. Not just today, but every day.

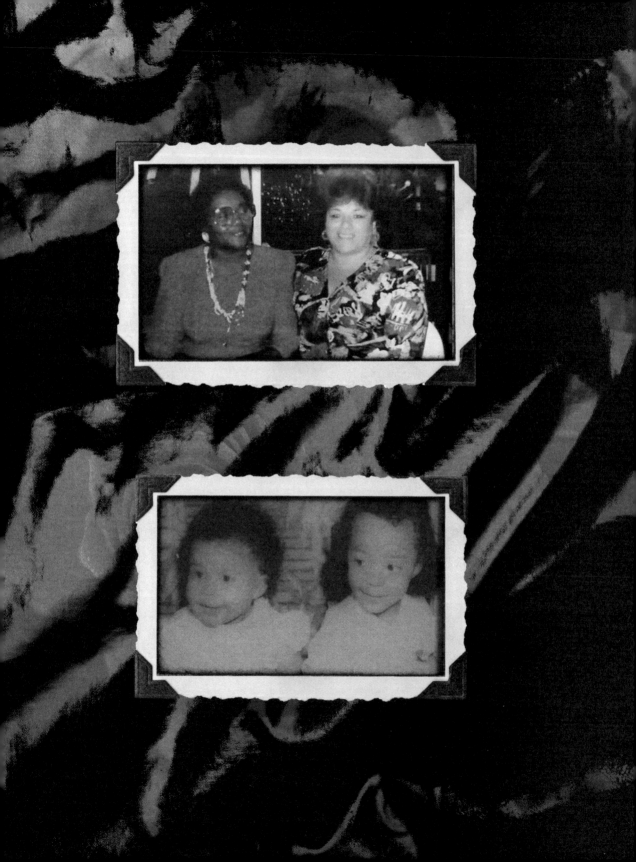

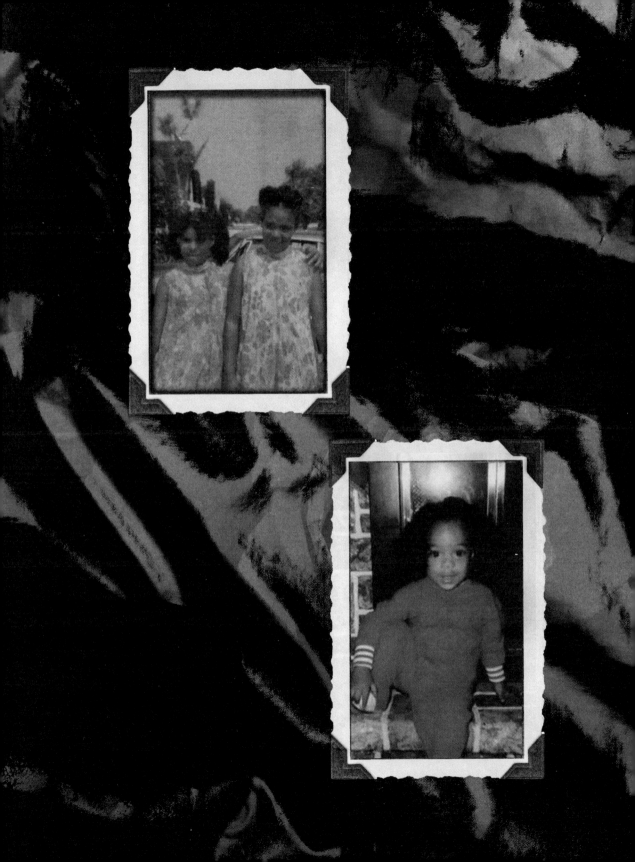

HONOR THE DEAD

While we all invite beginnings and the start of something new, endings are not a welcome sight. This is because of the way we are taught to see life: as something that progresses from start to finish. However, an ending is not final; it is yet another stage in the infinite cycle of birth, growth, decay, and rebirth. Death is a transition from one stage to another. We must acknowledge endings. We must move to the next stage of the soul's journey.

A remembrance altar can be created for anyone who has transitioned on—these are not just for family and loved ones. A remembrance altar requires the following items:

- Photographs of the departed
- Candles: use any colors that feel symbolic for you and the person you are honoring—white candles represent purification and peace
- Incense and herbs: copal, frankincense, myrrh, lavender, white sage, hummingbird sage, or any purifying blends
- Fresh flowers in a vase
- A keepsake of or from that person
- Letters
- A glass of cool water
- Offerings of the person's favorite foods or drinks

It's important to remember that creating an ancestral or remembrance altar is an affirmation of the person's life rather than continual mourning for a loss.

SANTA SANGRE
(HOLY BLOOD)

Our blood ties us to our fate. It holds the stories of our ancestral lineage, of generations of mysteries. Blood sustains life.

It connects us to our past, our ancestors. However, remember that it also connects us to our future, the children of our children, centuries ahead of us, and centuries to come.

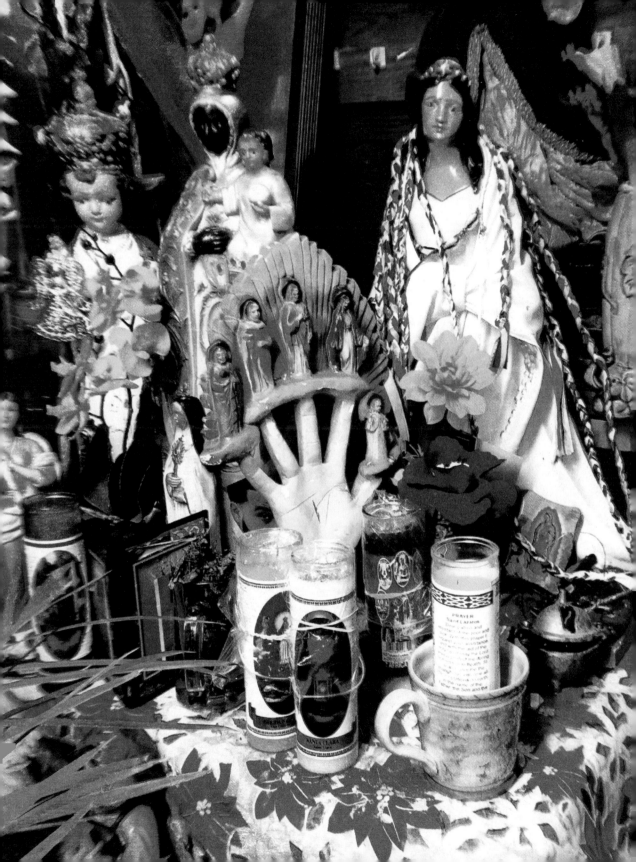

POWER AND PROTECTION

advocate for people, especially women and femmes, to step into their power. I don't mean this as some empty and clichéd motivational speech. I mean it sincerely, with the fierceness of a thousand tornados. Run, leap, dance into your personal power and reclaim your sovereignty.

Your opinion of yourself is your power in this world. Don't let anyone take your power away from you.

Personal power is just one attribute of the witch, but what does this power look like for Black and Brown witches and brujas when we live in a world where we are constantly told that anything but passivity and uncertainty is too aggressive, scary, or intimidating?

Other people's truths are often manipulation tactics. Outside opinions combine to weaken your innate power.

When I began the Hoodwitch, I was in a relationship with a Scorpio man who made significantly more money than me. Initially, he was a mentor, but I noticed that with each new level of success I received, he found more ways to belittle me or make insensitive comments to make me feel unsure about my creative decisions. He siphoned my power. He convinced me that I wasn't attractive enough to be photographed and that it was best for me to "stay behind the scenes," which weakened my place in my own business. He disguised his envy as "helpful suggestions."

Looking back now, I can't believe I ever allowed that little troll to take advantage of me. Despite my increasing success on the outside, on the inside I was empty and lonely. He told me that if I left him he would destroy me and my business. He wanted to see me fail without him.

One day, I worked up the courage to leave. I began taking weekly meditation classes with some very powerful healers and witches I had met in

my community. During these classes and lectures, I began to strengthen myself in psychic protection and spell work. I learned to see through the manipulation. It was obvious that his intention was to twist, confuse, and control. If you should ever find yourself in a similar situation with friends, relatives, partners, lovers, or co-workers, you need to get out of it as soon as you safely can.

In the end, I learned an important lesson about those who *truly* want to see me succeed and what that support should look and feel like. This man wanted to own me and control me, but you cannot own and control a witch who has claimed her power.

Your boundaries are a form of protective magic. Every "no" is a spell cast to protect you from unnecessary bullshit. The more you stand in your power, the more people start to realize that they can't play with you. Do not back down when someone challenges or threatens your livelihood or integrity.

What does embracing personal power feel like? It feels like ease. Personal power feels like authenticity, like stripping away the urge to perform for others. It feels like clarity and certainty. It feels like being okay with not being accepted by everyone.

You are not for everyone.

AFFIRM: With every ritual, I am reminded of who I am. I call back my power, all of the lost pieces of myself. I remember where I'm going. I actualize my purpose with confidence, structure, discipline, and reason, protecting my truth and manifesting my vision.

Every "no" is a spell cast to protect you from unnecessary bullshit.

PARA LOS HATERS

nvy is the opposite of love. Love celebrates the good of another; envy seeks destruction.

My grandma Sylvia was a firm believer in not discussing personal business outside of the home, especially with meddling gossipers who always seem to be around for the latest tragedy or misfortune in someone else's life. In our family, it was tradition to cover up newborn babies with blankets in public for the first month to keep them from receiving the *mal de ojo* (evil eye). Strangers could not touch a pregnant belly or touch or kiss a newborn's hands or feet. As both my grandmothers told me, you never know what type of energy a stranger is directing toward a mother or her child.

Protection from envy, the evil eye, and jealousy is nothing new. As a child I grew up hearing many cautionary tales about what sorts of negativity can happen if you are on the receiving end of ojo.

Many cultures have superstitions around the evil eye. An evil eye curse is prompted by jealousy and frustration. It is said to be placed on victims through a sinister stare. In Hindu cultures, many people believe beautiful babies are especially vulnerable to the evil eye because, well, they're beautiful, innocent, and pure. To deflect the evil eye, parents smear a dash of black soot or paste onto the baby's forehead. With this blemish the baby isn't quite so beautiful, thus deflecting the evil eye. In Mexico and many South American countries the mal de ojo is not taken lightly. El mal de ojo is believed to cause sickness as a result of the transfer of negative energy from one person to another. It is also thought that there are people capable of making others sick simply through intense looks, whether voluntary or not.

As a magical practitioner in the public eye, I take this elder wisdom seriously. Some of the worst cases of mal de ojo I have ever seen have come from witches and healers in spiritual communities who claim to be

more evolved than these "low vibrational feelings" but secretly use their magic against other practitioners for destruction, chaos, and confusion when they feel threatened or envious. This is why protective magic is so important. Learn to trust your instincts about who to choose for romantic relationships, friendships, work environments, and social groups.

Grandma Sylvia used to have a neighbor named Birdie, who was a *chismosa* (gossiper). Birdie was a large, loudmouthed Mexican woman with short, feathered hair who loved sitting in her tiny sun chair on the shared balcony next to my grandma's apartment door. Nothing gave Birdie more joy than talking shit and chain-smoking cigarettes. She always had something to say about any and every person who approached the building. Because she sat in one place all day and never moved, she knew everyone's personal business, and she took great joy in sharing it with anyone who would listen. I should say that she knew everyone's business except Grandma Sylvia's.

"Did you hear about the woman down the street? Her husband died— now she has no money," Birdie would say.

My grandma couldn't stand her, and she routinely warned us not to listen to the gossip Birdie shared. Grandma kept to herself for the most part, which drove the women in her complex mad, so of course they would say things behind her back. My grandma took no pleasure in the evil arts, like gossip and envy, and instead found pleasure in watering her beautiful houseplants and relaxing with her blue and yellow pet parakeets, both named Pretty Bird.

Birdie, seeing that I was the youngest granddaughter, always tried asking sneaky personal questions about my grandma, my mom, or our family when I saw her. She'd ask me if I wanted to come over to her house for treats and candies, but I knew that would be a death sentence. I was taught from a very young age to keep quiet and say "no, thank you" to any of her invitations.

My grandma didn't even have to say a word—she would look at me with dagger eyes if I began to spill too much about our personal plans for the day. Grandma had no problem with interjecting in Spanish or English to Birdie (she loved throwing in a mixture of both): "Don't you have your own grandkids to bother?"; "Worry about your own family!"; or her favorite, "Stop asking my granddaughter so many nosy questions, you cow!" She

couldn't stand listening to the chismosas in her building complex, and she made sure they knew it by shutting the door in their face midconversation. Grandma was a straight shooter.

"The less people know about you, mija, the better," she would say.

And those words of wisdom have come in handy throughout my life, especially in times when I've gotten great news on projects. I didn't scream it from the rooftops because I did not want my creative energy to be disrupted or my plans spoiled. It is important not to have the eyes of the envious glare on the start of good news; you wait until it's finished, and then you share. This also can be said for spell work: you don't tell people you're going to cast a spell. You simply do the spell and leave it be. That way the energy you're focusing on cannot be disrupted. Sure, some people like to believe that what is meant for them cannot be taken away by a malicious hater, but the reality is it's better to be safe than sorry.

If you have a chismosa in your life, you are going to need energetic protection and boundaries. When you're focused on your life, making big moves, or simply working on your personal healing, there are going to be people who want you to stay small, stagnant, and stuck. They're used to seeing a different version of you, one that lacks energetic boundaries or self-confidence or personal growth. Oftentimes this is because they don't feel confident to do the same or they are simply unhappy with themselves and don't want to see you evolve. Growth is scary for people who are set in their own patterns.

In a perfect world, defensive magic wouldn't be necessary, but let's get real—we aren't living in a perfect world, and we need to protect ourselves from destructive energy. Unfortunately, some of these haters can be people in your own family or your spiritual community or other—sometimes powerful—witches. How do you protect yourself from gossip and envy? Well, simple. You want to nip all communication and contact with this person or persons in the bud as soon as you feel the energy's dynamic shift. If you suspect a friend, family member, or coworker of sending you mal de ojo, it's best to trust your instincts and act fast. Protect yourself from their malicious slander and envy or suffer the consequences.

LIMPIA CON HUEVO

L *a limpia con huevo* translates as "cleansing with egg." It allows the doors to be opened and our auras to be cleansed and rid of anything that has been troubling us, especially the energy of a jealous hater. The use of an egg for spiritual cleansing is known to many cultures, as the egg is a symbol of fertility, regeneration, growth, and life. I learned it growing up as a distinctly Mexican tradition, but other meso-American cultures use limpias in their practice as well.

You can do this ritual on yourself, but it is typically done by another person. That person holds an egg and either rolls it slowly over your skin or waves it in front of your body like a wand. Start at the head and move down to the feet. Take your time—don't go too fast. Say some prayers as you cleanse.

This practice removes negative energy from the body as well as the environment. The egg works as a means of absorption. It is a container for stagnant energy directed toward you. Sometimes the egg will crack as the ritual is performed. This means it has absorbed as much energy as it can hold. You're getting rid of disruptive energy, so think of cracking as a welcome sight.

After the ritual is complete, crack the egg into a glass of water. Sometimes you will see cloudiness or images: these are signs. Interpreting the yoke will help you plan your next action, whether it be a healing bath, reversal spell, prayer, herb, or something else. While anyone can do this cleansing, if you would like the yoke interpreted, you will need to consult an advanced bruja or curandera. However, here are the general guidelines:

- Bubbles or whiteness pointing upward mean there is negative energy on you which may be causing you to feel tired or depleted.
- Needles, spikes, or points mean there is dark magic on you. Someone is trying to hold you back.
- Blood, black spots, or odors are a warning sign of something terrible present, like disease.
- If the water looks cloudy or milky, then the evil eye is on you.

To dispose of the egg, add salt to it and flush down the toilet.

For those individuals who work around people and are often seen and viewed, jealous onlookers are a given. Be wise and protect yourself.

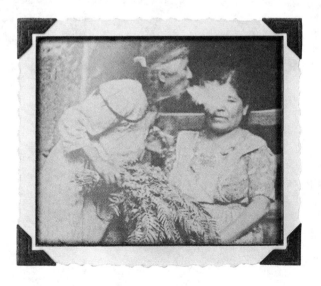

YOU ARE ON THE RIGHT PATH

DO NOT SECOND-GUESS
A GUT FEELING

Do not ignore this warning
or you will regret it in the end.
Your spirits and guides will
give you insight if you are
listening and paying attention
to who and what is worthy of
your energy and time.

FOLLOW YOUR INTUITION,
NOT THE CROWD

Trust your magic. Oftentimes we seek confirmation outside ourselves for messages that our intuition and guides have already shown us. Magic does not need validation.

True to their Piscean nature, both of my grandmothers possessed heightened intuition, or what many call psychism. I loved that they knew what was going on in me without my having to speak a word. In my teen years, this gift would save me from what could have been some pretty disastrous and scary situations. My grandmothers taught me to strengthen the muscle of my intuition. "If the vibe is off, we off." This has become a personal mantra, and it has never led me astray.

Pisces or not, it is difficult to differentiate between intuition and anxiety. Intuition is an ambiguous knowledge. It can be difficult to decipher in a single fleeting moment because it is a product of your rational mind and all you have seen and learned in the past. Your intuition arrives much like a sixth sense, a perfect awareness. A knowing. Anxiety, however, is an urge, a feeling, a worry, a discontent.

That said, we live in a fast-paced world where everyone wants and expects instant gratification, instant answers. Your intuitive insights can come to you at lightning speed, but if you lack clarity, you could learn a lesson from the hanged man in the major arcana of the tarot: there is power in stillness. Once you allow yourself stillness, you can start the process of either untangling anxious thoughts or hearing the call of your intuition. Pay attention to which thoughts carry the heaviest of your emotions.

Make a conscious effort to relax your mind, cleanse your space, and allow the messages to come freely. Ask for assistance and guidance from your spiritual team, whether a higher power or your higher self. Do not dismiss

Trust. In. Your. Magic.

the messages that are presented to you after meditating or praying on situations you have requested guidance for. Oftentimes people dismiss these subtle or very obvious messages as coincidence, but if you don't pay attention, how the hell are you supposed to receive? By honoring our intuitive skills and abilities we honor ourselves. Trust. In. Your. Magic.

Spirit work comes from a place of learning to trust your intuition by navigating methods that work or don't work for you. Learning to trust yourself is the most important healing practice. I have found that journaling situations that I struggle with in waking life, as well as symbols in dreams, visions, and words, offers me a window into my subconscious mind.

Journal exercise for enhancing your intuition:

- Begin with an affirmation: "I trust my own magic. My intuition aligns with lost rituals and guides me to a place of balance and inner peace."
- Review your spiritual goals and personal values.
- Ask yourself, what am I spiritually dedicated to?
- What is stirring inside me that seeks growth and illumination?
- How will I nurture this growth?
- Declare your spiritual journey out loud, light a white candle, and make your dedication to the goddess, your higher self, or whoever you choose.
- Take a ritual bath for purification.
- Cleanse and purify your home and workspace.

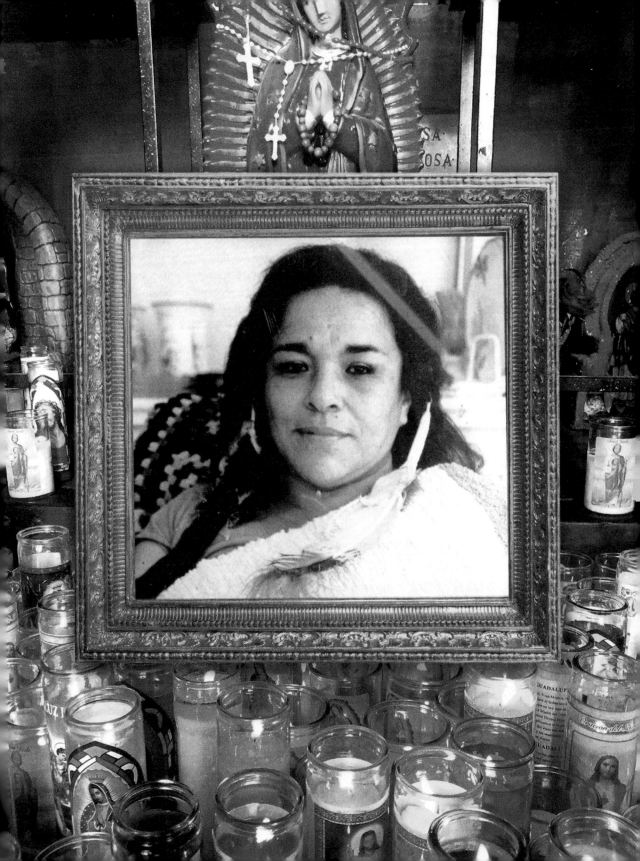

GRANDMA SYLVIA

I come from a family of strong women. I come from a lineage of love, beauty, power, and chaos.

It started with Grandma Sylvia, one of fourteen children. And then my mother, the eldest of eight children, six of them girls.

My grandma was a teenage runaway from Santa Barbara. She gave birth to my mother when she was only an adolescent herself.

My mother and her five sisters would later be adopted by a Southern Black family in Los Angeles. But they remained connected to my grandma, and I grew up with Grandma Sylvia very much a presence in my life.

My grandma Sylvia was Mexican, and our lineage traces back to the Yucatán, meaning we have Indigenous blood, which made sense, as my grandma always prided herself on her warrior spirit. She loved to fight, defend, and win. Especially with men. Once, she charged down the street

> I Was Born in Feb 21-1940
> my Mother named mes "yellow Rose"
> and because i cryed alot at School
> be cause the kids made fun of me.
> At that period of time not to many
> Indin chillun went to the School —
> because my father was indan mex.
> they kept my name Sylvia J. Palma
> Because I am an american mex indan
> they kept it that way.

after her ex-boyfriend and cut his leather jacket off his back. This was a fond memory that she had no qualms about sharing with all of the girls. Take no shit from a man. The greatest revenge is to keep surviving. Resilience has been in our DNA from the beginning. It is a part of our cultura. The women in my family always find a way to make it.

We are storytellers. We know the power of carrying events forward, of making sense of the world through story. Grandma Sylvia was the catalyst. She was a Pisces, of course, with a huge imagination, and it was always hard to distinguish in her stories what was real and what was something she created in her mind to make her life less painful. A true water sign: what she lacked in book smarts she made up for in the streets. She prided herself on her petite frame, her immaculate black winged cat eyeliner, and her teased Aqua Net hair. I will always remember her jet-black, almond-shaped eyes. My grandma's eyes looked as if they were always watching you, and they probably were.

With all the darkness in her life, there were also moments of light, of meaning, and with time, of deep understanding. My grandma worked during the summers of my childhood as a street vendor at the big fiestas in Santa Barbara. She sold cascarones, colorful papier-mâché eggs, which I'd help her make.

These were fun times—times I love to reflect on and how I like to remember her. However, her tough persona always came through. When my sister, my cousins, and I wanted to go out in the late hours of the night, she'd say, "The only thing open after midnight is legs." That was her way of saying no.

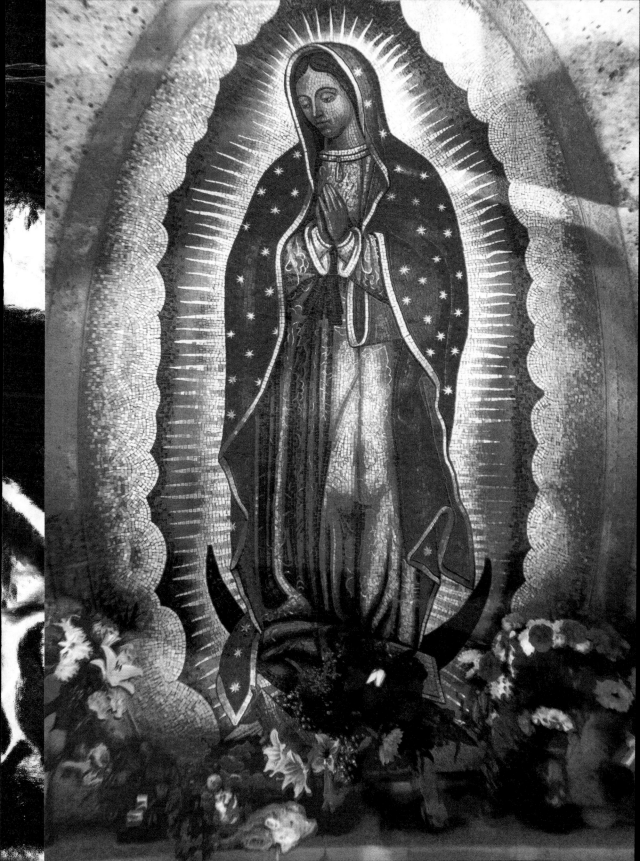

Grandma Sylvia spoke her mind always, at anyone's expense. No one ever had to wonder what she was thinking because, trust me, she would tell you. This woman was the definition of a spitfire, and the streets of Los Angeles spewed out of her pores. Standing at a petite 4 feet 11 inches, she was a hell-raiser, an activist for Brown and Black folks living in the city during so much racial injustice. She rose to every occasion boldly and without fear, like the waves of the roaring ocean. There was no glossing, no niceties, no fake small talk. She had a tone that could incite rage, fire, and tears from anyone she encountered. How well can anyone ever really know a complicated woman, especially a woman with a life like hers?

I remember dancing in front of the television to Madonna's "Like a Prayer" when I was young. The music video caused major controversy in the 1990s because Jesus was portrayed as a Black man and Madonna burned crosses. I was instinctively drawn to the imagery, the clothing, the lights and shadows, and the deep, pulsing rhythm. I had never seen anything like this, but I sensed that what I was seeing was a part of me, a part of the woman I would become. Whenever the song came on, I danced wildly in front of the screen. One day, my grandma Sylvia caught me and screamed, "Mija! She's a cochina!" (in Spanish this means "dirty tramp"). For some reason, Madonna really pissed her off. I never knew why because my grandma was no saint.

"But why is she a cochina?" I asked.

I loved Madonna. I thought she was cool and beautiful. The sovereign witch energy within me was already strong.

When I was ten years old, Grandma Sylvia came to stay with my family. I didn't want this "grumpy witch" in my orb, so I did what any magically inclined child would do—naturally, I cut out the soles of her shoes with razors and drew her a picture of a pig-faced monster with nasty words.

Unbeknownst to me, my grandma took the picture off my mother's bed before my mom could hide it. Many years later, I saw the picture in my grandma's memento trunk and laughed—she kept it all those years. How could I have thought this woman was so harmful?

Now, when I reflect on my grandma, I view her as a goddess, a fierce warrior goddess who commands respect and reverence. Her cunning and strong presence was too much for many people. I now recognize that being "too much" is true strength and power—which she left to me. I'm always speaking up as a result of her influence: raising hell and advocating for myself and on my own terms.

But the most important lesson Grandma Sylvia taught me was to protect my heart. I don't need someone to complete me—I can complete myself. In that way, we are similar. Yes, she was a lot rougher around the edges than I am, but this was how she learned to protect herself. The hard exterior was for her survival and safety growing up in a hostile and violent world where she was never afforded any softness. I initially took her unsugarcoated approach to life as being mean, but I think she teased me the most because I was just as stubborn and willful as she was. "Mija," she would say with a smile, "I'm coming back to haunt you when I die!"

TAPA BOCA SPELL

Tapa boca means "shut up" or "shut your mouth." There is an image on the outside of every tapa boca candle, and it speaks for itself: a woman with a cloth tied around her mouth binding it shut. This candle is to stop gossip and rumors. It is a form of defensive magic and should not be done frivolously. This is a spell used to defend yourself against someone who has targeted you first. It is powerful and intentional.

These candles come in a variety of colors. I like using a candle that is black on top and red on the bottom. You want the black to burn through the negativity first, before it burns to the red. The candles also come in black/green and also in solid black or red. The black and green are specifically used for matters involving jinxes or gossip, or destructive energy directed toward your money or finances. The solid black candle is a good choice for heavier matters, when you need to shut down envious talk completely. If you cannot find either of these candles, use a solid white or solid black glass-encased candle.

Keep my enemies' mouths shut!

Tapa Boca Spell

YOU WILL NEED:

Small square of parchment paper

Black pen

Knife or ritual athame

1 lemon

Spicy herbs such as chili powder, cayenne pepper, or anything that is spicy or bitter to the taste

Silver pins

Tin foil

Salt water

Candle

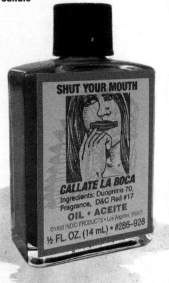

Anointing oil (Shut Your Mouth oil, Stop Gossip oil, or any oil that will be used to shut up the haters)

DIRECTIONS:

Write your petition on the parchment paper with the person's full name and birthday. If you do not have this information, focus your intention on this person onto the paper and write "enemy." Fill the paper with their name or simply the word "enemy" or "enemies." Repeat until it fills the parchment square.

Then turn the paper counterclockwise and write over their name "shut up" or "shut the fuck up" (if you're like me, you will choose the latter!).

Fold the paper away from you.

Turn counterclockwise and fold again.

Keep folding this paper until it is small enough to fit into your lemon.

Cut a slit in the lemon, making what looks like a mouth. You don't want to cut too deeply as you do not want to cut through the lemon—just enough to make a kind of pocket.

When the lemon is cut, place your spicy herbs in the pocket. The spice of the peppers represents what you want to happen to their tongue when they speak of you. You want their

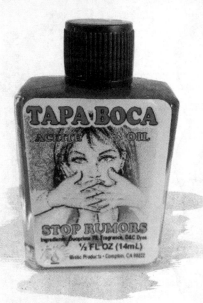

Dress the candle with the anointing oil and herbs that you are working with, and place it in the bowl of salt water on your altar or a space where it will not be disturbed. Do not blow out this candle under any circumstance. For protective or defensive magic, ensure that the flame keeps burning until it has completely burned itself out.

Focus your energy and intention on the candle, and say into it what you would like to happen, as in:

"Keep my enemies'
mouths shut!"

or

"Your words have no
power over me,
and the rest of the world
will not hear your lies!"

mouth to burn with fire; you want their words to burn their mouth.

Place the piece of parchment paper into the lemon.

Then take the pins and close the mouth of the lemon. Once the lemon is shut, place it on the foil with the shiny side up.

Close the foil over the lemon and focus your attention on it, visualizing what you want to happen. You want that person to shut their mouth.

Wrap the lemon in the foil and place it in the back of your freezer.

Leave the lemon there for as long as needed.

When you feel satisfied with what you've said into the candle, allow it to burn, and thank your guides.

Allow the candle to burn out completely, and once it has fully burned, dispose of it in a garbage dumpster far away from your home.

GRANDMAMA ALTHEA

When I think of hoodoo and what that means to me and my family, I can feel my grandmama's best-kept secrets. They are inside me. I can close my eyes and see the smoothness of her rich chocolate skin or the antique green kerosene lantern that sat on her bedroom dresser. The white candles, a clear glass of water, and her Bible lying across her bed, opened to the book of Psalms. I can smell the sweetness of a cornbread baking in her well-seasoned cast-iron skillet in her little house in the triplex she owned in South Central. Her big old silver bubbling pot of collard greens or the scent of black-eyed peas cooked to perfection on New Year's Day.

My grandmama kept alive the Southern hoodoo food traditions of prosperity. I grew up looking forward to going to my grandmama's house to eat. I believe her most powerful magic was created with much love, care, and attention in the kitchen. She made pink strawberry cakes from scratch and served them after a meal of sliced tomatoes with white onions and cucumbers soaked in vinegar.

Grandmama Althea's house had a very distinct smell. It is said that the human olfactory system, or our sense of smell, holds memories, and this familiar scent of my grandmama's home brings up memories of warmth, love, and healing. A subtle mix of White Diamonds perfume and a dusty gas oven heater. Oddly enough, after my grandmama passed away, I could still smell this scent in the hallways of my mother's apartment. When I asked everyone else in the house if they could smell her, no one else ever could.

My parents would take me to my grandmama's house when I was sick and they couldn't take days off from work. She would mix up some of her famous concoctions, usually involving fresh garlic, crushed aspirin, and orange juice. There was nothing that couldn't be cured with that mixture followed by warm noodle soup. She had a bottle of some type of strange

oil she would douse us with and rub on our chests, and I loved sleeping in my grandmama's big, old wood-frame bed. There was something so magical about having a fever dream in that bedroom, as she hummed along to soft gospel hymns or just made up a soothing melody. It is an undeniable fact that every child who slept in my grandmama's bed when they weren't feeling good instantly felt better. A grandmama's love.

I knew my grandmama was a deeply spiritual churchgoing woman, but what did that really mean for a Southern Black woman with deep conjure roots? Her healing felt as unique to me as she was. I couldn't have told you how I felt about it then, but it is deeply important to me today. My grandmama's practices were passed down strictly by word of mouth from mother to daughter. In this case, she passed them directly to me. I never saw my grandmama as being a witch or magical back then. My ideas surrounding witchcraft and magic were clouded in Hollywood nonsense. As a child I believed that witches were white, ugly, haggard, and mean. My grandmama was quite the opposite: she was Black and beautiful, well-dressed, and fabulous. Her demeanor was calm, and she had the most beautiful long magenta fingernails decorated with the same rhinestones and the same nail polish color for over twenty years. Tiki Punch nail polish was my grandmama's color, and getting her nails done was a ritual. After she passed away of breast cancer, I got a nail polish bottle tattooed on my left forearm in honor of her life: "Tiki Punch," on a small banner with flowers.

When I look back on my grandmama's life, I think of her as a healer, a *real* healer. A strong Black woman born under the sign of Pisces, with a smile that could light up any room. Soft yet strong. A Southern lady's charm. My grandmama worked for many years as a nurse in a Los Angeles hospital. She sang in her church choir and cooked delicious meals on Sundays. She also worked the roots and washed down her doorsteps with brick dust, and she made sure to teach us about conjure work and our ancestral roots working magic.

She taught me to never photocopy my hand, because someone could "read my life." To this day, I never set my purse down on the ground for

fear that I will lose money, literally and figuratively. I also have a thing about never allowing anyone to use a broom anywhere near me, because if they sweep your feet you'll have bad luck. If this happens, it is important to throw a pinch of salt over your shoulder or, if you don't have salt, to spit on the broom. Most important of all, never throw out hair when cleaning a hairbrush. It is always best to burn the hair.

Hair is sacred in magic of all cultures. It holds your essence, depending on where on your body the hair comes from, and once people get their hands on it they can make you do anything. In hoodoo, it is believed that if your enemies get hold of your hair, they will be able to control you and can even drive you crazy. Furthermore, if you throw your hair in the garbage, it is believed that a bird could make a nest out of your hair, resulting in you losing your mind and going crazy. The safest method to get rid of unwanted hair is simply to burn it. Yes, it smells horrible, but I practiced this for many years. My mother never allowed anyone to come into her bedroom during family events, because someone might go snooping around looking for items to use in a ritual or spell work.

I know this sounds strange to anyone who isn't familiar with hoodoo or conjure practices, but people who know the history do not fuck around. Jilted lovers, disgruntled neighbors, and hating frenemies can find a way to infiltrate your space. These are people you need to especially keep a watchful eye out for.

Shoes are another item you don't want to leave around, for fear someone could hot-foot you, which is placing powdered herbs in your shoes or in your shoe tracks after you leave your home. This method of magic can wreak havoc on your target's life by causing all sorts of terrible inconveniences.

All of these practices I learned from my grandmama. When I was younger, I always thought she was just superstitious, but these superstitions have a deeper and more nuanced history in our culture. As I grew older and more developed into my own magical practices, these stories made more sense to me. They connected me to my ancestors and to their form of magic, healing, and hexing.

GENERATIONAL CURSE

As a little girl, I was exposed to stories I probably shouldn't have heard at that age. I loved eavesdropping on my mother and aunt's conversations. During those conversations, I saw many tears from my aunts. I heard many stories of love gone wrong. I couldn't help but wonder if our family was cursed somewhere down the line.

I look back at all of their stories, and I see how many of the same themes played out in my own life and in the lives of my cousins. Generational curses are real and so deeply ingrained in our psyches that oftentimes we are not consciously aware of them.

How do we begin to break generational curses surrounding love? Will love always hurt? Will I always be too much? Will I always be too angry? Do I always have to fight for love? It has always been easier to hex than to heal. Healing is not linear, and sometimes it takes a few lifetimes to get it right. By no means do I think I've gotten it right, but when I look at the story of my life, and when I think of my grandmothers and the strong women we have in our family, I know that the source of our strength is fueled by passionate fire. It's a double-edged sword. We care too much, we love too hard. Love can illuminate or it can burn shit down.

Love is a power that I will always fight for.

Love is my truth. Love is my ultimate form, my essence and being.

I look back on my grandmothers' lives, *la sangre* (the blood), healing. I want to learn from our mistakes. Maybe this time I will get it right.

There is no one-size-fits-all, and what you might consider dark and evil, someone else might consider cathartic and affirming.

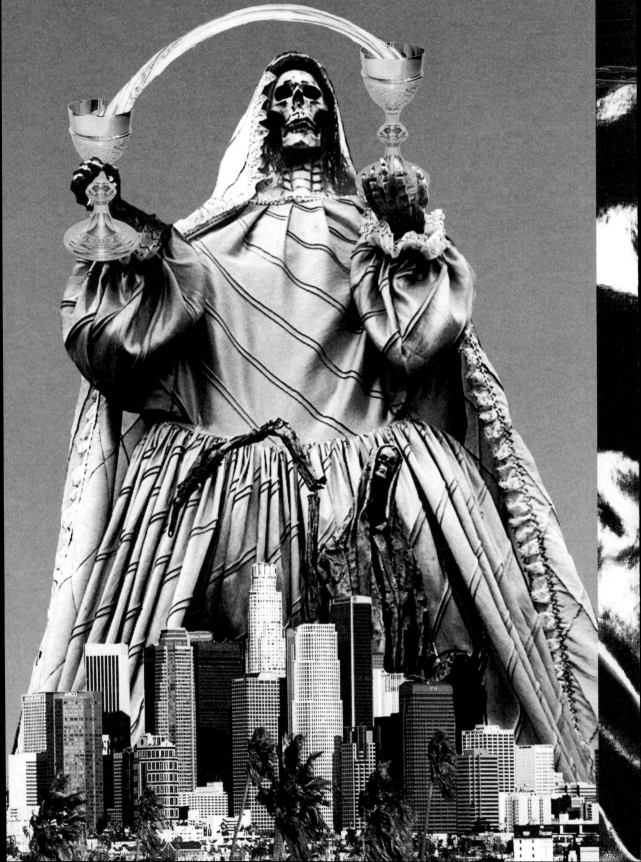

ROOTS

You better be careful or she'll put a root on you!" my mother's boyfriend Julius would tease me. Half joking but still serious, we all knew the implications of having someone "play in your head." "Throwing roots" or "casting roots" were common phrases in my household. "The root" is a direct reference to the use of herbs, roots, and other items that could be bottled, bagged, and hidden in or around a space to harm, or even create total havoc for, the intended target.

The term *root* stems from the hoodoo and conjure traditions of the American South. Hoodoo, not to be confused with voodoo, is an African American folk tradition—not a religion but a generational spiritual practice that was formed from the blood, sweat, and tears of the African diaspora and the enslaved African people brought to the Americas through the transatlantic slave trade. The knowledge of herbs, plants, roots, and their powers was a gift, and the secrets of our ancestors were handed down through the whispers of our grandmothers and grandfathers to their children and their children's children.

I hesitated to write about these concepts here because hoodoo is a cultural inheritance—not something you pick up and learn from a book. Hoodoo is in your blood. It is a birthright that has survived some of the worst circumstances of history and has been passed down from generation to generation. Most of the hoodoo practices in America have been held close to bloodlines, but recently hoodoo has gained more popularity with the rise of African traditional spiritual practices, the decolonization and reclaiming of Black people's magic through ancestral veneration and community rituals, and the reclaiming of our knowledge and gifts.

Like many others, I dismissed my grandmama Althea's wisdom as merely superstition, but as time passes, I am reminded of just how important these stories and practices are. The preservation of our families'

healing practices is a gift for our children in these times, and their children in future times, and their children after that. The truest gift of this healing practice is that it is in our blood, so long as we nurture the gift and pass it down.

Culture cannot be bought or sold. Hoodoo and root working are practices that many of our elders took very seriously and that we seemingly now take for granted. Many of these practices have died with the elders who lived them firsthand. With the emphasis on Christianity in the Black community, our hoodoo roots were deemed merely devil worship, demonic, or—as my father liked to call it—funny stuff. But hoodoo is quite the opposite. It is a spiritual tradition rooted in survival.

I miss my grandparents so much, because I feel there is so much more information they had that is no longer available to me. There is wisdom in their storytelling—in the traditions and certainly the secrets they kept in order to survive. I am grateful to have been born into these mysteries, and it is why I seek to continuously grow in my own spiritual practice. Our elders and ancestors died to maintain the only rooting we had back to our original land and to our people, our connection to the spirits of the earth, the soil, water, air, and fire, which kept us grounded and sane in a time when our families were ripped away and taken to a new world. Their ingenuity in developing languages and coded ways to preserve our magic cannot ever be washed away. I feel that now is my time within my bloodline to hand down the stories, the practices, and the understanding of why these traditions hold power, and to hopefully awaken that curiosity in other Black people to rediscover and connect to the elders in their lives. Without them, our magical legacy is lost.

RED BRICK DUST POWDER

Conjurers and root workers in the South have used red brick dust for protection for a very, very long time. It is even said that Marie Laveau herself, perhaps the most renowned and beloved herbalist, conjurer, and root worker in history, used it in her practice. This spell is believed to have been started in New Orleans's French Quarter.

Why do we use red brick dust? It aids in home protection and protection from theft of every kind. The brick is symbolic of protection from the outside elements. Bricks are strong, and their redness is linked in spiritual practice to our ancestors and blood. With this practice, you are literally taking old red bricks and using them in a powerful blend for protection from intruders both on the physical and spiritual planes.

Red Brick Dust Powder

YOU WILL NEED:

Flat, hard surface

Cardboard or thick paper

Red brick

Small amount of rum or whiskey

Goggles and handkerchief or mask

Metal hammer

Mortar and pestle

Funnel or rolled-up paper

Jar or vessel

DIRECTIONS:

Find a hard, flat surface, preferably outside, and lay out a large piece of cardboard or thick paper on top of it. Keep in mind that you're going to be hammering on this surface, so don't choose a table or glass or anything that could be damaged by a hammer. The cardboard is to catch the brick pieces as they crumble.

Set your brick in the middle of the cardboard and sprinkle it lightly with rum or whiskey (this is your offering to the brick for the work it will do for you).

Say prayers of protection over the brick (pray to your gods, ancestors, spirits, or the universe).

Cover your face with a handkerchief and use goggles for your eyes. These will protect from the red brick dust or pieces getting into your eyes or your lungs.

Use your hammer to start breaking the brick apart. You'll find the right strength and speed as you go along.

Continue to pray over the brick as you hammer it into smaller and smaller chunks.

Once you've gotten the brick down to small chunks, transfer a piece of brick to your mortar and pestle.

With your pestle, pound the chunk of brick, grinding it into a fine powder. Do this with all the brick chunks, small portions at a time, until the entire brick is dust.

Say another prayer of protection over the brick. Then use a funnel or rolled-up paper to transfer the red brick dust to a mason jar or vessel of some kind.

Label and store it until ready for use.

HOW TO USE BRICK DUST IN SPELL WORK:

Cleanse your door and threshold, then sprinkle red brick dust over the threshold to keep out intruders of any kind.

Mix the dust with protective herb powders and sprinkle over thresholds for powerful protection.

Create a reddening mix with the dust and urine, ammonia, or vinegar, and use it to wash down your doors and thresholds (this is great for protection and prosperity).

CREATE YOUR OWN REALITY

One of my earliest childhood memories comes from around the age of four. My parents both worked, and they left me with an elderly Black woman who watched me. I remember it was a sunny day, and I was sitting at the kitchen table with my coloring book and some crayons scattered over the counter. The woman snatched the crayon from my little fingers with one hand, and with her other hand she squeezed my hand until the blood rushed to my fingertips. She told me that little girls didn't write with their left hand, that Christians wrote with their right hand only. "That's the hand of God," she said.

What does that even mean? I was too young to know she was clueless, and I was afraid to tell my parents what had happened, but I never wrote with my left hand again. This incident is not surprising. It's what many Black and Brown bodies have endured from the beginning of time: the force of being told to fit the norms of society, often against our own will and at a young age.

As an adolescent trying to understand myself, I found solace in music and in my imagination. When I was around twelve years old, my cousin lived next door to a girl named April. Her family was extremely religious, very Christian. She invited us to her church. I will never forget going to the youth Bible study wearing a Marilyn Manson T-shirt. It was my favorite shirt, and I wouldn't have thought to wear anything else. Being Black, Mexican, and "alternative" was definitely not cool at this time—well, at least not as much as it is in the mainstream now. Having colored hair and piercings was not something people of color welcomed or appreciated, especially not in the Baptist church. I remember going to her church begrudgingly and being mocked and made fun of by the Christians there. They were cold, judgmental, and cruel. I knew I would never be like them.

I didn't want to live any of the kinds of lives I saw unfolding around me. I loved losing myself in the magic of films like *The Rocky Horror*

Picture Show, and "Don't dream it, be it" became the most powerful mantra to me, one that I still live by. Tim Curry's character, Dr. Frank-N-Furter, represented freedom to me. He was glamorous, powerful, rich, sexually liberated, and fabulous! Looking back on it now, he was a powerful creator of realities. Baby witch Bri was majorly inspired by this.

I look back on this time in my life and smile, because I never really cared what anyone thought of me, and that is a quality I've always loved and admired most about myself. I believe that is ultimately what a witch is, in the sense of the witch as an archetype. The witch is a fierce rejection of society's expectations. This was in my blood. I give credit to no one but myself.

It's important as a witch to be a challenger. If there is one thing I will say to all witches in the world, the people who work the hardest to humiliate you or to bring you down or to "other" you will be the same people who someday sing your praises. It is important to remember that these individuals have no roots—their souls are as flimsy as a feather in the wind. I have always known that my uniqueness would allow me to flourish and take me places that other people could never imagine going.

I create my own reality.

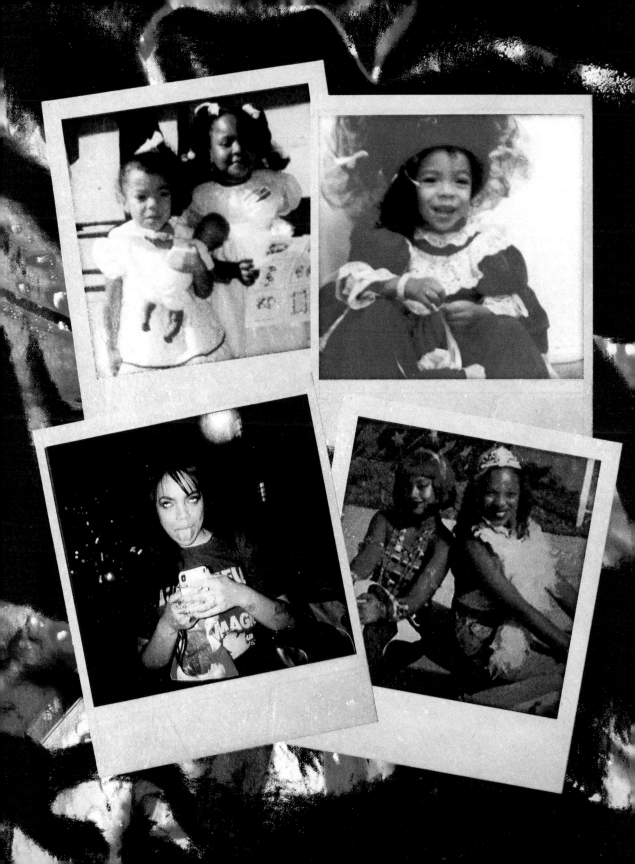

REVOLUTION

Sex with a witch can be a blessing or a nightmare. Do not cross us. We do not turn the other cheek.

Witches paved the way for sexual liberation and sexual freedom, and we use sex to perform our most powerful rituals and rites, from initiatory rights to simple seductions for power and fun. We have charmed and seduced our way through the centuries, rejecting puritanical beliefs and practices. Seduction is the work of the witch. Thus, persecution has been the story of witches around the world as well. We are accused of enchanting men simply because we exist, own land, are independent, resist the social order or rules, or hold a position in the community that others envy or want. We are the force that spurs sexual revolution, and we resist any tradition that is not on our own terms.

Sex is the purest form of magic. A witch is not, and has never been, afraid of seduction, sex work, kinks, or fantasies. We invented them.

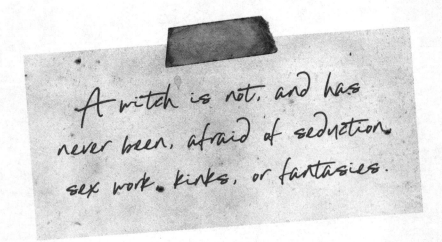

A witch is not, and has never been, afraid of seduction, sex work, kinks, or fantasies.

SEX MAGIC

Paschal Beverly Randolph was one of the first known philosophers of sex magic. He believed the orgasm was a powerful connection between our world and the divine realm. "True sex power is god power," he wrote. As such, the moment of orgasm is ripe for magical purposes.

The life force energy we harness in sex is potent but neutral. There's nothing attached to it. It's like fire or water; it's not bad or good. You can burn down your house with fire or create warmth.

In nature, sex is about creation. With sex magic, we can utilize our sexual energy to manifest what we want. Like all spells, it starts with intention toward an outcome.

There is more to sex magic than just having passionate sex all the time. That would be an easy way to manifest everything you want in your life, but nothing comes easy. Sex magic is not a parlor trick; it is a skill to be practiced. You'll have to find methods to tap into what works for you to build these magical muscles.

Sex magic is not love spells. It's about manifesting an outcome. Masturbation can be an effective form of sexual magic, a personal ritual. Others have orgies, using a collective focus to raise energy. Candles can be used to amplify, and herbs to sweeten or spice. Manifestation comes in many forms: Sacred prostitution. Tantra. Chaos magic. Ceremonial magic.

Sex magic is not limited to heterosexual sex. We all have masculine and feminine energy within us.

Sex workers can often be powerful witches. They have autonomy over their body, they understand the art of seduction, and they are conduits for people to reveal their most vulnerable selves. There is great power in being unashamed of your sexuality.

If you're going to practice sex magic with a partner, do you discuss it beforehand? That is your choice. Sexual magic with a willing participant,

with a partner working in tandem, can be ideal. But if your partner isn't a practitioner, you can still have sex with your own specific focus in mind. As long as the sex is consensual, the intention doesn't have to be.

Sex magic can be used to strengthen other spells; it works like adding gas to a fire.

I have always practiced sex magic even before I knew what it was. Sex magic is its own practice. It's tied to everything. What's the point of being a witch if you're not using sex magic?

Sex Magic in Practice

Techniques include but are not limited to chanting, breathing practices, internal cultivation of energy, meditative practice, visualization, massage, diet, eye gazing, varying ways of touching yourself or your partner, hand and body positions, pelvic movement, ejaculation control, and control of orgasmic energy.

It takes time and practice to incorporate these techniques into a sex magic practice.

Start with your intention: write down, on paper, a very clear objective. Or if you have a tarot card that is symbolic to you, or another type of image, study it before you start your sexual practice.

Set an allotted amount of time for your ritual, and create a ritualistic space where you won't be disturbed. Clear your home, burn resin, set the tone with candles—the less artificial light the better. Turn off distractions, including phones. No TV, and no false stimuli.

Slow down. Focus on sensuality. Start with deep breathing. Stimulate your arms, feet . . . This is a slow burn. You are building energy.

When you're ready to orgasm, to release the energy you've built up, hold your objective/image in your mind. Feel all the energy focused on

your desired outcome. See your orgasm as a wave of energy that is being pushed out into the universe.

After you're done. Enjoy the peace in the moment, and let the intention go. You don't have to keep asking or checking on the spell. Like all magic, if this is within your highest good, if it's aligned with your purpose, it will come to you quickly, but you can't hyperfixate on it. Let the universe do its thing.

We all long for a partner with whom we can experience a beautiful and deep energetic connection. However, meeting someone with whom all your energetic frequencies connect is very rare. Be discerning about who you open your sexual energy to. Do not practice sex magic with a partner who creates a space of coercion; a sexual parasite drains energy and power, and there is great potential for things to go wrong. Sex magic is meant for reciprocal energy and communication. In a couple, this practice can help you manifest harmony and energetic flow.

If you or your lover harbor emotional pain, fear, shyness, feelings of inadequacy, or a history of sexual abuse, are overly concerned about perceived physical imperfections, have difficulty climaxing, or are subject to erectile dysfunction or porn addiction, these things will need to be overcome before you can safely practice sex magic.

As a sacred, heart-centered practice, sex has the potential to transform and expand your perception of and relationship with yourself, your lover, and the universe. It opens the path to a broader, fuller, deeper experience of life. Sex as a ritual can release many negative sentiments that have been repressed and open the doorway to other magical realms.

I am a witch, not a saint.

—Michael Cardenas

JEZEBEL OIL

Jezebel oil is a perfume that gained fame in the twentieth century. It is concocted from flowers, herbs, and other ingredients, and it gained a fast reputation among its clientele, mostly sex workers. Known by some as Cleo May, this perfume oil is historically used by women and witches to encourage men to open their wallets. It can also be used to attract a financially secure lover or partner who will support you monetarily.

Today I see Jezebel oil as a helper for anyone doing what she needs to do to get that cash. Jezebel oil isn't only for seduction; it is a powerful scent of success. If a woman uses Jezebel oil to get herself noticed by the higher-ups or to attract a promotion or raise, then more power to her. What I am suggesting is this: if you are working hard and utilizing a little magic to help yourself get ahead and make the individuals at the top take notice, then this oil could be useful in your spells. This oil is not limited to sex workers and businesswomen; it is most useful in industries where tips are part of your pay.

Make that money.
Don't let it make you!

Always make moves in silence. Psychic transparency is self-sabotage.

Jezebel Oil

YOU WILL NEED:

A glass jar

Florida water

Jezebel root

Lovage powder

Orris root powder

Licorice root

Rose petals, dried

Grapeseed oil (high quality)

DIRECTIONS:

Cleanse your glass jar with Florida water.

Charge the Jezebel root with your intention, with powerful commands of what you want to manifest. The more detailed the better. For example: I will make more money every shift.

Break down one piece of Jezebel root and put it into the glass jar. Add a pinch of the lovage powder, orris root, licorice root, and rose petals.

Pour in enough grapeseed oil to fully cover the entire concoction. Do not overfill or overcrowd the jar.

Shake the jar every day for about two to six weeks, depending on your desired potency.

You can place a dab of this oil behind each ear, behind the knees, or in the crevices and creases of the elbows. The floral and musky scent will keep the person you're controlling on the hook.

I have always
wild woman, the
the sexually
glamorous, wicked
deviants of love

admired the demonic feminine, empowered, witches and sexual and history.

BLACK MAGIC WOMAN

I have always admired the wild woman, the demonic feminine, the sexually empowered, glamorous, wicked witches and sexual deviants of lore and history. From the ancient goddesses and beautiful ocean sirens who used their voices to lure and seduce unsuspecting men at sea (before devouring them) to the exotic dancers and sex workers who dance in the glow of neon-colored lights, the stories of bad girls, harlots, jezebels, and sluts fed my imagination growing up. I worshipped the unruly wild women who couldn't be told what to do. I lived for decadent and glamorous women with elaborate beauty rituals. From Cleopatra to the blood countess Elizabeth Báthory, I understood there was something innately magical and terrifying about a woman in charge of her body—a woman who understood sex as a strategic tool to get what she wanted . . . or needed.

A facet of the seductive witch that is often lost or unexplored is the duality of her experience: the pain *and* the power. The darker side of her seduction is that she is labeled and hated for this power and strength, and that hatred fuels her even more. As a society we encourage women to be selfless, subservient wives and mothers, and yet we ignore the other side of the coin: the sacred whore—a woman just as embodied, just as fulfilled, and just as capable of being a wife and mother. Why is being true to one's innate power, charisma, or sexuality such a threat? Why are we taught to be the Eve and never the Lilith?

BEAUTY, SEDUCTION, POWER

Beauty, seduction, and power—I have incredible respect for these three qualities whenever I see them in a witch. It requires autonomy to be fierce, sexual, and free.

I've always gravitated toward the darker side of things, even in Disney cartoons. I loved when Ursula the sea witch transformed herself into the beautiful dark-haired seductress Vanessa, luring away Eric, Ariel's prince charming, and enchanting him with her voice. While most saw Ursula as a horrible bitch, I saw her as the full embodiment of her magic. She used her magic to go after what she wanted—and why shouldn't she?

The witch is the only archetype that defines itself, unlike queens or princesses, whose definitions come from others. The witch is a shape-shifter, a glamorous seductress in a penthouse or a toothless hag waiting in the woods. She lives a life true to herself. She sleeps with whomever she wants, buys what she wants, lives where she wants, enjoys what pleasures her, and removes what doesn't. The witch is unafraid to use what she's got to get what she wants—be it by sex, spell casting, or persuasion.

The witch bows to no one.

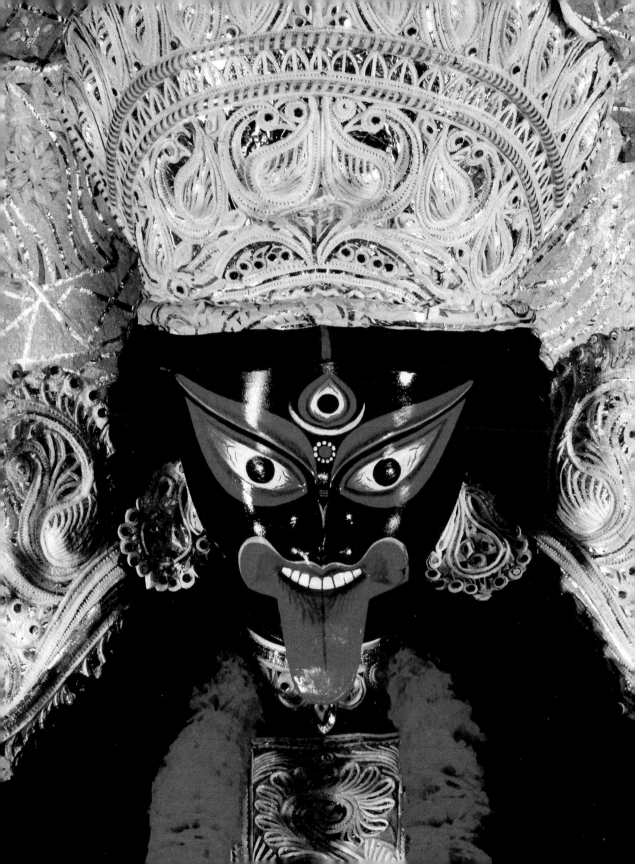

AGUA DE CALZÓN
(THE PANTY WATER SPELL)

This spell is controversial and not for the faint of heart. *Agua de calzón* (panty water) or *té de calzón* (panty tea) has been used throughout Latin America and in many different folk magic practices throughout the world. The spell can be used as a love spell or as a means to dominate a lover.

In the past, witches would take their used or soiled underwear and soak them in a pot of boiling water. Dried herbs were added to make a tea, which was sweetened with sugar or honey and then fed to a target or spouse or lover. It is said that this is a potent means to enchant lovers or bend them to your will.

Some of you are probably appalled at the idea of feeding your lover used panty water, but hey, no one ever said witchcraft was all rose quartz and essential oils! These are the secrets held by our *tías* and *abuelas* (aunts and grandmothers). If you think the panties tea is next level, you will probably want to skip over the menstrual blood love bondage spell too.

"Personal concerns" (blood, urine, semen, discharge) have been used in spell work and brujería since the beginning of time to enhance the power of love and domination spells.

Historically these spells have been used for straying spouses and partners who tend to flirt a lot. I'm sure many of you are asking, "How can anyone be so desperate?" Well, desperate times call for desperate measures. Why does anyone practice any spell anyway? However, this is something to take into consideration: Do you want to really keep a cheating partner in your life? Or someone who doesn't want to be devoted to you?

The Panty Water Spell

YOU WILL NEED:

Dirty underwear or a worn sock. Use a sock if you're trying to dominate this person and have them "under" you. For the underwear, the dirtier the better—they should be worn for five days. This does not mean you don't bathe; it means the same underwear should be reworn for the duration of this process. It is important to have the essence and fluids of your body infused. The underwear must be red or pink—no black underwear!

Whole cinnamon stick (not powder!)

3 cloves

Orange peel

Sugar (palm sugar)

Spring water or holy water

DIRECTIONS:

Prep your underwear by cutting out the crotch.

Place the crotch of the underwear or sock and the cinnamon stick, cloves, orange peel, and sugar into a pot of boiling holy water or spring water.

Recite what it is that you would like to happen. For example,

Spirit, body, and soul of _____.
You will drink this water
and you will not look at,
listen to, touch, kiss,
or love any other
_____ [insert gender]
that is not me _____ [your name].

I dominate you,
_____ [their name],
and you will drink this water.
I will live in your head,
your body, your soul,
and your _____ [sexual parts].

Repeat three times.

You can repeat the making of this water as many times as needed.

It is important that when casting a spell such as this you are loving and forceful in your words. You absolutely want to feel empowered and in a grounded state, not crying or feeling shitty because your target has hurt you. Just like with any spell you're casting, you will need to focus, ground yourself, and compose yourself to strengthen your intention!

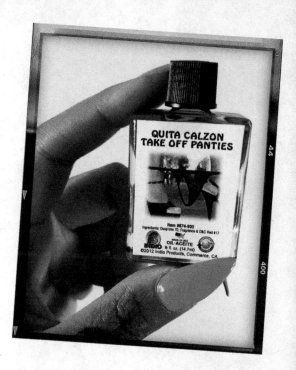

Warning: Do not bind an abusive person to you! Binding an abuser to you will not change them!

SUCCUBUS

The succubus is the demonic feminine. She is the primal and dark essence of death and rebirth. She uses sex for pleasure and power, not love. She eats men alive and rips away their energetic forces, and for this she is feared. The succubus is a woman that is suppressed within us and persecuted among us. Sex, to her, is a means to an end—to dominate, yes, but also to heal, on her own terms.

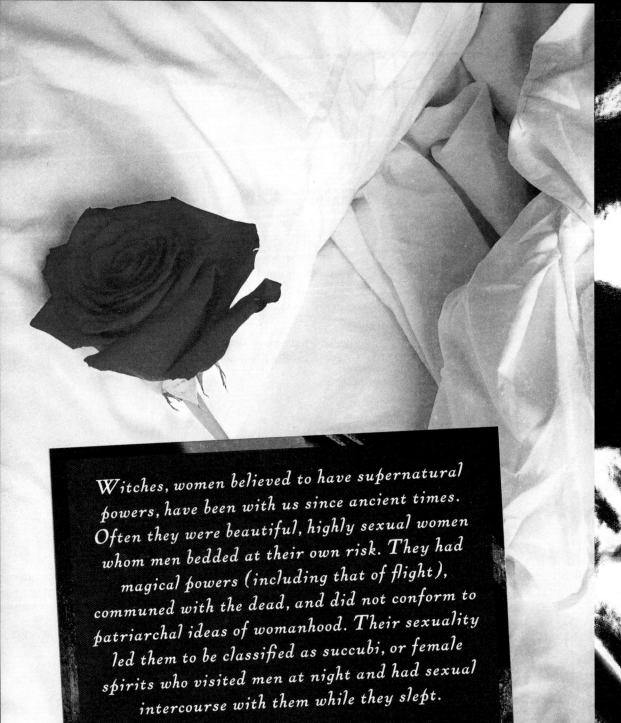

Witches, women believed to have supernatural powers, have been with us since ancient times. Often they were beautiful, highly sexual women whom men bedded at their own risk. They had magical powers (including that of flight), communed with the dead, and did not conform to patriarchal ideas of womanhood. Their sexuality led them to be classified as succubi, or female spirits who visited men at night and had sexual intercourse with them while they slept.

—Serenity Young

THE DEMON

When I met the Sagittarius, I knew I had met my match. He was pure chaos. I thought it was chemistry. When you're having really great sex, you overlook bad behavior that isn't compatible with you. This person went from my ideal to my nightmare.

He questioned and challenged me. Our sexual appetite for each other was insatiable. At restaurants he would feed me, and no expense was spared. Lavish dinners, hotel rooms with room service, strip clubs—we were inseparable and unstoppable. He was the Boris to my Natasha. I would say the Gomez to my Morticia, but he wasn't half the man Gomez was (I would find that out later). I gravitated to him, and he to me. We were passionate and filthy, dripping in lust. We couldn't keep our hands off each other. He loved being in control and dominating me, which was something I never imagined was possible. *I* was always the dominant one in partnerships, especially sexually. *I* was the succubus.

The Sagittarius brought me to the top, and that high was quickly followed by a descent straight into the depths of hell. This was someone who knew the game of manipulation; he preyed on my weaknesses and despised my success, but I was blinded by what I thought was love—attraction, seduction, chemistry.

Then he would take his love away from me. I hated myself and blamed myself for allowing him back in every single time. He wouldn't argue, but he would ignore me for days and then pop up as if nothing had happened. I kept quiet.

Over time, I noticed his wandering eye and sexual deviance. He compared me to other women, made me feel as if I wasn't beautiful enough. And yet I stayed. I stayed in fear, because I'd never been with anyone who had this kind of power over me. He knew how to play on my fear of abandonment and my insecurities. The darkness that once attracted me to him was far from sexy. It was toxic. It was mental illness, drugs, and abuse.

Real love does not require you to suffer.

When the illusion lifted, I saw him for what he truly was: a textbook narcissist, an abuser, a misogynist. The once vain and mysterious hot goth guy he thought he was had self-destructed into an impotent, sad, and even more destructive human being. Everything he prided himself on was gone.

Why was I so afraid? I have never been weak, I have never allowed *any* man to control me or influence any aspect of my life.

I was a powerful witch.

Right?

I felt defeated and stupid. I was so ashamed and embarrassed. You don't know how deep or how far it's gone until you're really in it. We always hear stories and scoff, "Well, why didn't she just leave?" In hindsight, I wish I had.

He broke me, but in time I built myself back up. Piece by piece.

I began to focus on healing myself with the support of my friends, shadow work, and therapy. I felt it was important for other women to know they can become whole and free from a narcissistic abuser, that all is not lost. No matter how dark, you can always find the light within yourself again.

I can't tell you all how many times I thought about hexing him, cursing him, and using all of my magical energy to destroy him. Instead, I chose to cut all energetic ties. I chose to channel every ounce of that rage into my work and back into myself. This was the most powerful thing I could have done. I had never looked and felt more beautiful, confident, and powerful. I exercised, meditated, and met with other powerful witches across the country in ceremony. My business was better than ever. I even got a huge job designing a cosmetics line. So many doors and windows opened for me when I released the energy of that demon dick parasite.

Real love does not require you to suffer.

GEMINI

My journey into motherhood was confusing and scary. I was so young and had no idea what the hell I was doing. During my pregnancy I began to have very strong psychic visions. I was visited by my ancestors, who would come to me in the form of painted white-faced elders sitting around a campfire.

Most dreams women endure in their pregnancy are very psychic. This is a time of union and synthesis within the body. I was growing a human inside me, which, to be quite honest, was fucking terrifying.

Up until this point, I had no real responsibilities. What did I know about becoming someone's mom?

During this time, I was very connected to Grandma Sylvia. She knew I was pregnant before I told anyone. I will never forget the phone call I received from her. It was suspicious. She told me that she had a dream about fishes, which is symbolic. I laughed and told her, no, I wasn't pregnant, but all it took was one look at me. She squinted and raised an eyebrow. "It's a boy," she said, rolling her eyes. I had tried keeping it secret from her, but she knew. She always knew.

My pregnancy was easy. I had never felt more powerful, strong, and beautiful. I loved watching my body shape-shift and transform into a home for my growing baby. I was thrilled to find out that my best friend, Michelle, was pregnant too. Our babies would be born only a month apart.

Pregnancy heightened my senses both physically and spiritually, I have never felt more connected to spirit than during that time. Aside from my intense dreams, I felt as if I were living between two worlds: the spirit and the material. During this time, I wasn't sure how to utilize or understand this energy, but I kept dream journals by my bed and wrote in them daily.

I had never known
a more beautiful soul.

My Gemini son was born with a Taurus moon and a Virgo rising. I have never known a more beautiful soul. I had never experienced this kind of softness. I would be his fiercest protector, and I knew I could kill for him. I held him and smelled his little head for hours.

LOSS

rief cannot be contained; it is an ocean that will swallow you whole.

 Each day will ache a little less, but only when you allow the waves of grief to flood your being. When they knock you down, you stand back up again. You become your own lighthouse. Sometimes that means drowning and being reborn. Again and again.

In time, I will learn to forgive myself. In time, I will heal. In time, this emptiness will be filled with love and growth.

Saturday, your life path number would have been six. I will never forget you.

SOLACE

HONORING PREGNANCY LOSS THROUGH RITUAL

Consciously choosing to terminate a pregnancy or the involuntary loss of a child—each comes with its own grief. The pain is usually dealt with in private.

Religion, society, and patriarchy shame us into believing that miscarriages and abortions should be kept hidden, silent, and locked neatly away never to be discussed outside of our personal journals or therapist's offices. The impact of external judgements can be devastating but are minimal in comparison to the way we judge ourselves. I refuse to contribute to that narrative. Why should I water down or censor the emotions that come with the heaviness of miscarriage or the choice to end a pregnancy?

Abortion and miscarriage can have a significant effect on the physical, emotional, and spiritual well-being of the person who experiences either. The feelings of confusion, frustration, doubt, isolation, and sadness are real. The wounds of pregnancy loss are something many people carry with them for the rest of their lives. It is a silent wound that over time eventually subsides but never goes away.

Not everyone who has had an abortion has feelings of guilt or grief, and there is no shame in that. Continue honoring yourself and reconnect with the wisdom of your decision. You did what was best for you at that time and should embrace your sovereignty.

Ceremony for Pregnancy Loss

Give yourself the right to grieve. When I could finally say that to myself, I was ugly crying, but it was one of the most important parts of my spiritual healing journey.

All grief is different and can't be rushed. I created this ritual for myself after the loss of two pregnancies. I hope that it will inspire people who have been through this before and may still have unresolved feelings to create their own meaningful ritual for healing.

You may perform this ceremony as many times as you need. It is suitable for anyone who has had abortions, miscarriages, or stillbirths. You may do this by yourself, or couples can do it together. A temporary altar can be set up if you find one helpful.

The new moon phase is ideal and the perfect time for releasing ceremonies.

YOU WILL NEED:

Music

Incense

Paper

Pen

Two candles

DIRECTIONS:

Create a sacred space. Set a dedicated time where you can ensure that you will not be disturbed. If you share a living space with people you do not wish to perform the ritual with, schedule a time when they will not be present.

Play your favorite music. Silence all other electronic devices.

Burn incense that is calming to you.

Get comfortable: take a relaxing bath or shower, dress yourself in clothing that makes you feel comfortable.

Open any windows that you can.

Set your intention to unburden yourself of any self-judgement and begin to forgive yourself. Take your time and experiment with what intention feels right for you or your partner. By way of example but make it your own:

It's not my fault; my body is beautiful; I am worthy of unconditional love.

I have a right to grieve. My feelings are valid.

Write a note to the potential soul before you start the ceremony and keep it with you.

Light two candles, one for you and one for the potential soul. Let them burn out. You can replace each candle for as many days as needed. I use white seven-day candles.

If and when you feel appropriate, you may burn the note and scatter the ashes in nature.

BE CAREFUL WHO
YOU FALL IN LOVE WITH
LOVE SPELLS

When I was a little girl, my aunt Marilyn told us a cautionary tale. She warned us to be extremely careful about who we used love magic and spells on. As the story goes, one of her friends placed a love spell on a man she wanted, a man who was already taken and was quite the womanizer. She went to the botánica and bought candles and herbs, and used drops of her menstrual blood to place a strong love spell on the man. The spell worked, but man, did she regret it. This man became infatuated with her. He wouldn't leave her house. He became lazy, refused to work, and didn't do much of anything, and all the while he continued to cheat on her. A love spell does not fix a man's flaws, and a womanizer may still be a womanizer no matter who he loves. The spell she cast was binding, but she was so desperate for this misogynistic man's affection that she was willing to use her energy and power at the highest cost: her life and mental well-being.

Beware using love magic from a place of desperation. Working out of desperation for any person to love you rarely, if ever, works the way you envision it. Generally, these spells end poorly, and they can often lead to unhealthy obsession and violence.

Love is a powerful source of magic. When you use it on a person who is not aligned with your highest good, you are inviting in a world of unresolved trauma and reversal work that can cost you your life if you are not careful. Always consider the character of whomever you're trying to enchant. If this person is a piece of shit who has treated former lovers and partners like trash, what makes you the exception? Why waste your precious energy and magic on someone who will probably do the same to you?

*No one can love you
like you can love yourself.*

I made this mistake only once, and I learned the hard way. On the night of a Scorpio full moon eclipse, I thought it would be a great idea to cast a love spell on a Scorpio man who I'd had a long on-again, off-again history with. We were friends with benefits for over a year. I loved him but never wanted to be honest about my true feelings toward him, so I thought using a love spell would be the best idea. It wasn't.

In true *I Love Lucy* form, I accidentally switched two different love oil bottles for dressing my candles. Instead of using the Chuparrosa, I dressed the candle with a strong Come to Me oil, vaguely gave it my focus or energy, and lit the candles. I should've known better, as my intuition and my gut felt so off when I did this spell. My guides were sure to never let me forget this lesson, because what happened after this little ritual of mine was quite comedic. I had been talking to a few different guys online—nothing too serious—but after this candle, my text messages and dating site messages became filled with some seriously weird people. Weird in a bad way. I had put vague and desperate energy into the spell, there was no real intention behind what I was doing, and I attracted the same energy in response. This included everything from aggressive stalkers to truly imbalanced individuals who were not at all aligned with me for any reason other than to show me that magic, especially love magic, is not to be taken lightly. I had to ride out this time in my life. I did cleansing baths and reversal spells to move on.

I always advise clients and friends to think really long and hard and trust that who is meant for them will be aligned, not forced not tricked. No one can love you like you can love yourself.

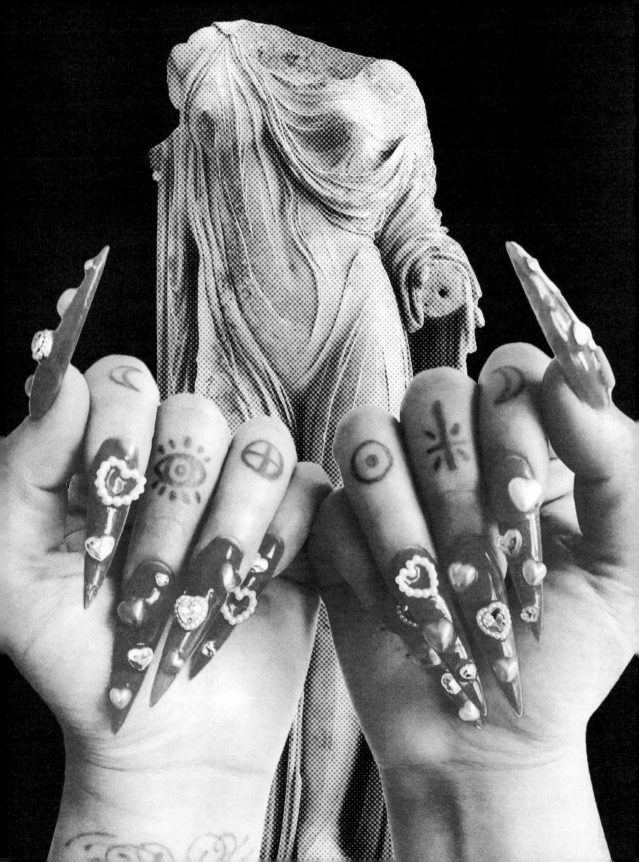

Self-Love Spell

YOU WILL NEED:

Mirror

Pink figure candle

Rose petals

Rose oil

Your favorite perfume

DIRECTIONS:

Take a long bath or shower.

Put on your favorite music.

Get naked.

Sit in front of the mirror.

Gaze deeply into your own eyes.

Appreciate your beauty:

I accept myself.
I am love.
I am lovable.
I am loved.

Repeat as many times as necessary.

Take the pink candle and place it on your altar, with the fresh flowers and things that make you feel beautiful and loved. Dress the candle with the rose oil, and spray yourself with perfume.

Light the candle and repeat your mantra. Do this ceremony every Friday or whenever you feel you need a self-confidence boost.

This spell should be cast on a full moon night, preferably in a Venusian sign or on a Friday (Venus's day).

CUTTING CORDS
RECLAIMING YOUR POWER

Cord cutting rituals are used to sever energetic ties between you and another person. This is not exclusively for love relationships: it can be for unhealthy friendships, family, or anyone you are ready to disconnect from. Cord-cutting allows you to take control of situations where you are feeling overextended or manipulated.

Cord cutting can bring up negative feelings from the past, or about this person. This may be something important that you need to let go of. It is not typically an overnight transition. Be willing to move forward. Keeping a journal can help you track how your feelings are progressing.

May all of my power be returned to me!

A Cord-Cutting Ritual

YOU WILL NEED:

Black candle

Paper

Black pen

Scissors

DIRECTIONS:

Light a black candle.

Write the person's name on a piece of paper, place it under the candle, and burn the candle as you work the spell.

Envision any and all cords and etheric tethers that are or have been attached to any past lovers being shortened, cut, and removed. You can use scissors to symbolically go through the motion of cutting any attachments.

Speak these words:

I release all lovers from the essence of my body, mind, and spirit. You have no power to control my heart or soul. Your energy is no longer useful to me. You are not wanted or necessary. Your pain will no longer torment or cause confusion, chaos, or emptiness in my life. I release you and any and all emotions of unworthiness. I am worthy! I am deserving, and I am powerful. I now call back my essence, my energy, and all of my life force that has been shared with you. May all of my power be returned to me. You are released from me for today and for eternity, and so it is.

GODDESS ARCHETYPES

Goddess archetypes are personifications of various elements of our psyche. They hold all the power of creation and destruction, and are buried deep in the subconscious. When I want to get outside of the restraints of my human form, I draw power and energy by pulling from goddess archetypes.

Psychoanalyst Carl Jung defined archetypes as models that all people recognize. We all fit multiple archetypes, regardless of gender. I connect the most with Venus, the goddess of love and beauty. In my sex life, I pull from the goddesses of seduction. In work life, I require warrior energy. Often, I take on the role of a healer.

While there are many different goddesses, these are the ones that have influenced me the most. Each of them is worthy of their own book, volumes even; I'll share what's most important to me. If you are compelled to do so, you should research further. A goddess's knowledge, magic, and strength can bring you divine wisdom and transformation. Honor them. Talk to them. Embody their power.

Become what you are afraid of.
Think that you are a beautiful spider
covered with diamonds.

—Alejandro Jodorowsky

> I am the one who alone exists,
> And there is no one to judge me.
> For though there is much sweetness
> In passionate life, in transient pleasure,
> Finally soberness comes
> And people flee to their places of rest.
> There they will find me,
> And live, and not die again.
>
> — Nag Hammadi, "The Thunder, Perfect Mind"

Lilith

Lilith represents our defiant selves—what we stand up for and how we assert our own power.

Lilith is the original sinful female. Adam asked God for a partner because he noticed that all the animals existed in pairs, and God told him that though he was perfect and didn't need a counterpart, God did not want Adam to feel lonely and granted his wish. God made Lilith of the same earth as Adam and brought them together. Lilith was beautiful and spirited, and was happy to keep Adam company in the paradise that was the Garden of Eden. However, Adam insisted she play a subservient role, so she fled to the mountains beyond the Garden of Eden. After she left, Eve was created to be Adam's dutiful counterpart.

According to the Old Testament, Lilith was created in beauty but was led into temptation by the sinister angel Samael, who led her down a path of depravity through the hedonistic decadence of earthly desires. The Bible links Lilith to the Book of Isaiah, in which she is noted as being sentenced by God to live in exile in the desert due to her unruly inclinations. For four thousand years, she has been known as a winged demon who haunts pregnant women and kidnaps babies. That's bullshit; those are stories told to keep women obedient. It's still a popular theme in horror films.

On top of her supposed infanticide, the Talmud portrays Lilith as a sexual predator. She is a woman of the night who takes advantage of men

sexually and tantalizes them while they are asleep. With her story, the elders were warning men not to sleep alone or else a beautiful sex demon would come and get them.

In astrology, the asteroid Lilith is known as a darker planet—the part of our astrological chart where we stand up for our most natural selves and fight for our inner wild. The wild woman Lilith is the part of our chart where we may use our sexuality or power to assert our innermost selves, not gracefully but with unmistakable power, and to free ourselves of social strictures. As a result, her position in our chart may also be where we feel we may be most misunderstood, shamed, and victimized.

An understanding of Lilith activates us to live as we want, not by any other rules than our own, and to tend to our deepest needs and desires. Accepting the shadowy aspects of life in our charts, our lady Lilith brings taboo matters to the table and opens them up for discussion. She is the root chakra, the core, speaking for our inner wild. Look in your chart to see where Lilith falls, and she will bring insight into your soul's deepest source of nourishment and heal the shame society so often puts upon us as natural beings from birth.

Lilith's story can be reclaimed in this era, when women are standing up against oppression worldwide, and serve as an icon for the men who are fighting by their side. For more about Lilith, I recommend reading Deborah Grenn-Scott's *Lilith's Fire: Reclaiming Our Sacred Lifeforce.*

Venus

Known as the morning star, located between the sun and the moon, and the brightest planet in the sky, Venus represents matters of love, money, compassion, sexuality, food, beauty, confidence, wit, and charm. Acting as the co-ruler of the maternal element in astrology (the moon is the first ruler), Venus acts as a guide through the mystical trance of unconditional love.

On a bad day, she may be jealous and overindulge, but her goodness radiates through her gentle demeanor.

Venus was one of the first goddesses who believed in having sex for pleasure. She's the originator of friends with benefits, throuples, threesomes . . . you get it? Plus, Venus did not believe that a woman should belong to a man. She was a free and fun-loving type of woman who wanted to do what she wanted with whom she wanted. Yes, my Taurus sun (which is ruled by Venus) totally relates.

She was birthed from sea foam, after Saturn defeated his father Caelus to rule the sky. Caelus's blood and semen dropped into the waters after Saturn castrated him. Emerging from the waves in full adult female form, Venus's beauty could make anyone with a pulse blush. As payment for the use of lightning bolts, her father offered her hand in marriage to Vulcan. The arranged marriage to Vulcan proved to be an interesting pairing, as Vulcan was notorious for his unpleasant looks and demeanor. Unhappy in the marriage, mainly due to sexual frustration (Venus and Vulcan never had sexual relations when married), Venus is widely known for her affairs. As the paramour of many famous gods, most notably Mars, she produced several offspring. Her beauty, charm, pleasant demeanor, self-confidence, and sophistication won over many men.

As she flies through the air in her chariot made of swans, Venus graces the sky with her merriment, sensuality, and lovely sensibility, teaching us all that love doesn't have to be hard. We should not have to work for popularity or intimate connections. Our gracefulness and laughter is more than enough to attract good company and affection.

A vanity table is the perfect altar for Venus. A mirrored table is ideal. We honor her glory on Friday by making offerings. She likes all things associated with beauty, glamour, and decadence. I like putting out red roses, perfume, and a small dish of good quality honey.

Venus's story resonates with every culture, gender, and living creature in the world. She shows how one cares and demonstrates love to others, their inclinations and tastes, their palate, what gives them pleasure, how

they may be inclined to sacrifice their happiness for those they care for. Venus is the goddess of all things that inwardly matter—security and harmony—and teaches us to live the bon vivant life. Honor your inner Venus. When you invoke her spirit, she will bring all the luxuries and goodness life has to offer.

All acts of love and pleasure are my rituals.

—Doreen Valiente, *Charge of the Goddess*

Hathor

Hathor is an Egyptian goddess (also called Het Heru) known for beauty, fertility, and ability to activate all the material pleasures in life. Her form is a white cow. Sometimes she's depicted as having a sun crown with horns. She was born to the sun god, Ra, and became known as the Eye of Ra because she protected her father and his essence. She is also the Egyptian goddess of cosmetics. Hathor is revered for her ability to elevate her beauty with cosmetics and charm others through glamour magic, which she was able to do through her dancing and beauty. She is the original enchantress.

As the fertile mother of the Egyptian gods, Hathor's gift is that of love. When she is willing to give love, it's said that her eyes glow gold. When she facilitates love between two parties, Hathor says, "I command you" to set the magical spell casting of love that she brings to them. She is important because Hathor is the protector of women. She is the goddess of mothers and the nurturer of all women. She was served and worshipped by priests and priestesses alike.

Kali Ma

Kali Ma, a Hindu goddess, is considered to be the master of death, time, and change. She is associated with sexuality and violence but is also a strong mother figure. She is attractive to mortals and gods and is worshipped in eastern and southern India. A yearly festival, the Kali Puja, is held in her honor on the night of a new moon in the Kalighat Temple in Kolkata.

There are several traditions of how Kali came to be. One story tells of the warrior goddess, Durga, who had ten arms, riding on a lion or tiger in battle with Mahisa, the buffalo demon. Durga became so angry that a form of Kali bursts from her forehead. Kali, a black goddess, went wild and ate all the demons around her. She strung their heads on a chain that she wore around her neck. Finally the mighty Shiva stopped Kali's attacks by lying down in her path.

Another version of Kali's birth recounts that Parvati shed her dark skin, which became Kali. This blackness is symbolic of an eternal darkness that has the potential to destroy and create.

A popular story involves Kali's escapade with a band of thieves. This group wanted to make a human sacrifice to Kali and chose a Brahmin monk as the victim. The thieves dragged the monk to the statue of Kali, and suddenly the statue came to life. The goddess was so enraged by their plan to kill a monk that she killed all the thieves and tossed their heads around.

Kali is often portrayed with blue or black skin and wears a painted or gilded Bengali crown. She has many arms, each of which holds a sword, dagger, trident, chakra, lotus bud, whip, or shield. Her most common pose in paintings is as the slayer of demons, dancing with one foot on a collapsed Shiva and holding a severed head. She wears a necklace of decapitated heads. Her expression is frightening, displaying a red tongue sticking out of her mouth.

Kali is said to live in cemeteries. She reminds us that every minute is destroyed in the cycle of time. All things that are born must die and decay. She is not a goddess to take lightly.

I turned to Kali for help in writing this book. Through mediation, in bowing down to her, she helped me dissolve my limitations and liberate myself from old attachments.

SANTA MUERTE

I graciously bow to you.
Cleanser of deception and bringer
of divine light.
Shield me with your cloak of
protection and shroud me in
your mysteries so that I may
emerge anew.
Beautiful lady of death, there is
no obstacle that you cannot destroy.
So be it.

TAROT
AN INITIATION

Tarot is a mirror into the soul. But let's get real. Questions about love are what bring us to the tarot. Love, sex, and money are almost always the main focus of any reading. Are they cheating? What kind of love will this be? Will I find new love? Is this the relationship for me? It is difficult to pull cards when we don't feel great. When we are in a negative state, we are quick to see negative qualities in the cards, and it takes great effort to see the good and positive traits. When working with tarot, I prefer to set aside the polarities of negative and positive, and try to objectively see what messages the cards have for me.

The placement and interactions between the cards is important. Pulling more than one card will add nuance to a reading, but the cards I describe below will typically bring clarity to any reading.

Red Flag Cards

There are certain tarot cards that I have always associated with betrayal. I try to remain objective, but these cards shouldn't be ignored when presented to you if they come up in your relationship readings. Despite this warning, chances are you won't listen. You'll pull card after card, or pay for reading after reading, asking the same questions about the same red flags. I get it: love makes us do crazy things, but until you start paying attention to what your guides are trying to show you, you'll be stuck in the same cycles.

Swords. Tarot's swords are double-edged; they represent conflict, and peace. A lot of times swords represent overthinking and getting stuck in our head. It's time to get clear about what we want. In general, I don't like to see a lot of swords in a love reading.

Three of Swords. This is the heartbreak card: three daggers in a beating heart. Disappointment. Depression. Confusion. Conflict. Trauma. Betrayal. The third sword can be a third party who's interested in the

relationship and creating chaos that leads to heartbreak.

Seven of Swords. The classic liar and cheater card, and one of the sneakiest cards of the tarot. If you pick this card in a relationship question, get to the bottom of what is being hidden from you. The tarot is telling you that the person you are involved with is lying to you about something.

Ten of Swords. You are about to be backstabbed by someone you trust. When pulled upright, the situation can be remedied. When pulled in reverse, there is no coming back from the situation.

Three of Cups. Three is a crowd and not fun to see in a reading when you're asking about a dynamic between two people. There's another person in the relationship who isn't supposed to be there. When this card is reversed, it alludes to an ongoing deceit, like cheating.

The Devil. Unhealthy attachment. Cheating. Abuse. Violence. Addictive energy, including sex addiction. Dangerous sexual encounters. This can be a fuck boy you're having a hard time disengaging from. It may represent: Feelings of powerlessness. Being trapped. An unhealthy dynamic. Dependency. You've lost your sense of self-worth. The sex may be good but it will leave you feeling bad. This is not it.

The Tower. This is not a card I want to see in a relationship or love reading. Things are about to fall apart in unexpected ways. Destruction. Upheaval. The rug being snatched from beneath you. Break ups. Divorce. This card is the limit. If the relationship can survive this destruction, space will open up for a more honest and sound foundation. Sometimes destruction is a good thing. This card can come up in situations of abuse and violence. It's time to open your eyes and be honest and open about where things are going. Pay attention.

Honorable mention: **Five of Pentacles**. Typically this card suggests financial struggles, which can strain any relationship, as well as rejection, abandonment, and loneliness.

Lucky Love Cards

If things are going well, you don't need the tarot to tell you that. But sometimes, the nagging voice of doubt is hard to ignore. How do you know when you can trust your intuition and when you are allowing yourself, for whatever reason, to be deceived?

When things are feeling good, here are my favorite reaffirming love cards that come up in spreads:

Ace of Cups. This is a card of renewal, hope, and potential. The beginnings of new love fulfilled. There will be mutual consideration and understanding while the foundation is still blossoming.

Two of Cups. Two equally enamored participants eager and willing to pour (emotionally) into the chalices (wants and needs) of their partnership. A welcome sign for all romantic partnerships. Union, harmony, balance, and understanding.

Ten of Cups. In a love reading, this is a beautiful representation of a balanced home and stable relationship. If there is a desire for a more serious connection, your relationship will deepen. This is a card of emotional fulfillment and equilibrium, long-term relationships, and happy family.

Four of Wands. A great card that suggests success and stability. Your relationship is going well, and you are laying down the foundations for marriage. This is a card of celebration, harmony, peace, marriage.

The Empress. You've been doing the necessary work on yourself and are now invested in sharing your nourishing and supportive energy. Be prepared for stronger unions. If you have been trying, this card can be indicative of a pregnancy.

The Lovers. This is one of my favorite cards to see appear in a love reading. The Lovers do not share a surface-level connection, their union is a soul connection. This card represents loving bonds, clear communication, alignment connection, and kindred spirits.

Catch a Cheater Tarot Spread

Shuffle the cards.

Meditate on the information you want to find out.

Ask the question in a way that is clear and concrete. It's important not to lead the cards into giving information because it may be inaccurate. It's best to let the cards crack the code. Ask, "What is happening in my relationship at the moment?" or "What information is pertinent to me?"

Pull six cards and place them in a pyramid shape. Read each row from left to right, starting at the bottom and working to the top of the pyramid.

1. Where your suspicions are coming from.

2. The foundation of the relationship. Are you on a steady path or rocky ground?

3. Ways the relationship can be improved.

4. What information is being concealed within the relationship's dynamic?

5. What you can do to improve the relationship or situation. Is there any chance of a reconciliation?

6. The definitive answer.

Self-Love Tarot Spread

Close your eyes as you shuffle the cards.

Allow your breath and heartbeat to harmonize with your hands as you shuffle.

Think of what makes you happy. When ready, pull four cards:

1. What you love about yourself.
2. What you need to work on to build self-confidence.
3. The obstacle standing in the way of you attaining personal greatness.
4. Your hidden potential.

Write down the date and the cards that you've pulled to keep track of your personal growth.

MAGIC

THE ART OF RITUAL

Ritual is the backbone of magic.

A ritual is a repetitive physical, tangible act performed for a desired outcome. Creating meaningful rituals connects us to deeper parts of our spiritual practice. They bring balance to our busy lives. They connect us back to the why.

Daily rituals like lighting a candle or washing the floors are therapeutic. Taking a spiritual bath with intention gives me peace amidst chaos.

What is the difference between a routine and a ritual?

Intention.

A morning routine is typically done with your mind on autopilot. You wake up, brush your teeth, get dressed. A morning routine becomes a ritual when these mundane necessities are done with focus on a desired

> *Let my worship be within the heart that rejoiceth, for behold: all acts of love and pleasure are my rituals. And therefore let there be beauty and strength, power and compassion, honour and humility, mirth and reverence within you.*
>
> — Doreen Valiente, *Charge of the Goddess*

feeling or outcome. When you put on your makeup, are you going through the motions, thinking about all the things you have to accomplish in the coming day? Or are you painting your face as though you are preparing for a day of battle?

Any act can be mundane or ritualistic depending on your intention. I like my Sunday ritual of watering my plants to make sure they're nourished. I like preparing meals to bring my family together. Cleaning my home makes me feel protected and grounded; it is a ritual I take very seriously. Regardless of how big or small the task, putting intention into action can turn a routine into a ritual.

Magic rituals have magical intentions. Some spiritual practices require elaborate and sometimes demanding rituals to achieve the desired outcomes.

The ritual is the act from which all magic is formed. We use candles, color, fragrance, sacred objects, offerings, and symbols as components of ritual. I love rituals; they are my connection to my magic and to the universe. There is peace that comes with ritual. Clarity. Rituals can be as elaborate or simple as you'd like them to be.

The habit of gratitude is a self-honoring ritual.

Ritual is the backbone of magic.

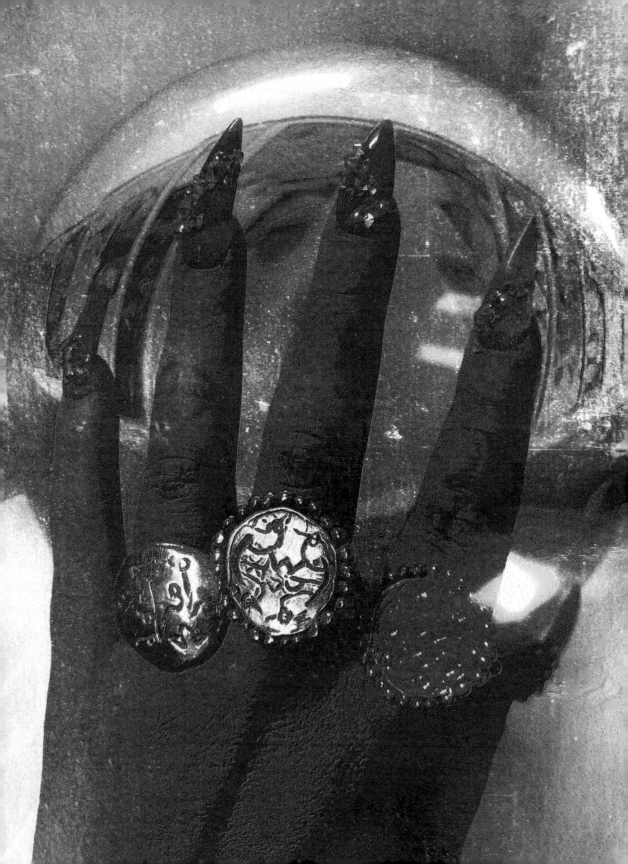

HEALING IS NOT LINEAR

hat is my authentic self? Who am I? What does the world want to hear from me?

As I've grown into my practice, I have realized that the energy I put toward my magic, like the moon, waxes and wanes. There is a special kind of magic in being vulnerable and open about your anxiety, in finding community with others who don't live in overly polished, perfectly curated lives.

Witchcraft, at times, can be ugly and messy. Sometimes it's anxious and dark, and that's okay, because it's also beautiful, transformative, and healing. Healing is not linear, and neither is your magic.

I have spent a great part of my life and career burning myself out. Overworked, overeating, oversleeping, overdrinking, and completely out of whack. How can I create meaningful magic when I'm too exhausted to make my own dinner? How do I manifest my wildest dreams when my anxiety won't let me get out of bed? How can I cultivate wellness when I don't feel good?

A big part of having a meaningful spiritual practice is honoring cycles and phases. Magic should feel complimentary to your lifestyle; it shouldn't be a burden. Give yourself the time you need to feel aligned with your practice. Honor yourself in a realistic way.

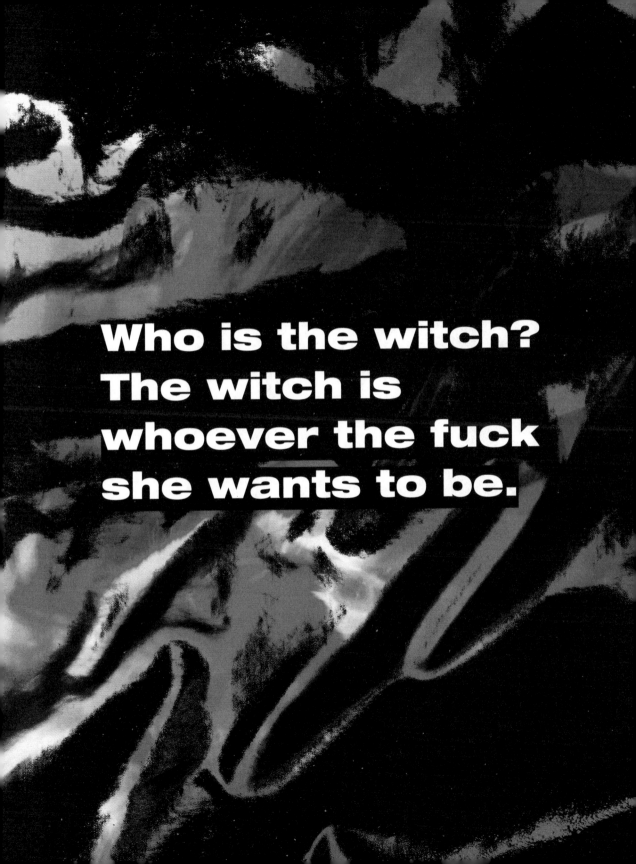

Who is the witch?
The witch is
whoever the fuck
she wants to be.

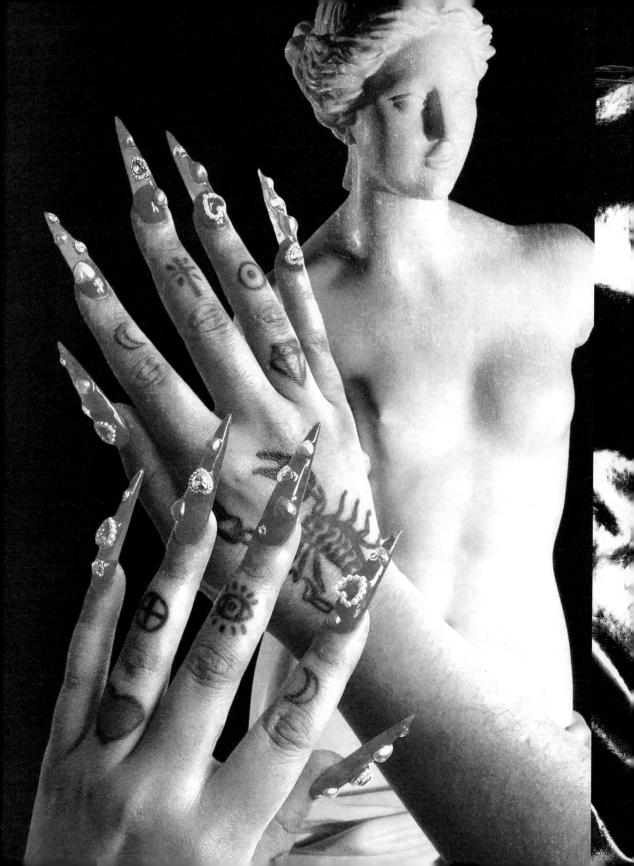

SELF-WORSHIP
GLAMOUR & BEAUTY

I worship my body so the Goddess may use it as her vessel.

Glamour is one of the oldest and most powerful forms of magic to me. It is an illusory spell, an undefinable quality that lures and attracts people into your realm without their understanding why. This is an art form: knowing yourself, learning how to play up certain qualities, and embodying them fiercely and unapologetically.

I use glamour as an act of resilience in a world that wants you to feel guilty for loving and pampering yourself. I don't care if it sounds lazy and self-indulgent. I'm into self-worship. It is great healing magic. I am dedicated to honoring my physical vessel.

Beauty is a ritual and it is my favorite. I find inspiration from ancient gods and goddesses, mythological vampires and other villains, nature, horror movies, all the weirdos of the world, Little Richard, Eartha Kitt, Divine, Zsa Zsa Gabor, Grace Jones, Jayne Mansfield, and Tim Curry as Dr. Frank-N-Furter in *Rocky Horror Picture Show*. My philosophy is, "Don't dream it, be it!" If you don't have it naturally, buy it. I'm all for personal transformation and reinventing your look as many times as it takes to feel like the most authentic version of yourself. You can transform yourself into whatever you want to be; who gives a shit what anyone else thinks?

Decorating Your Vanity Table:
A Sacred Altar to Yourself

My mother's vanity table when I was young was my favorite altar. It was immaculate. Full of lipsticks and bits, baubles, and bottles. I loved dousing my Barbie's hair in Mom's Obsession perfume.

My vanity altar is where the glamour magic happens. It is anchored and set with the most intention and detail. My vanity stores secrets: jars of creams, oils, and my many, many, favorite fragrances. I keep photos of

women whose style I admire and who have lived bold and unapologetic lives. Currently: Josephine Baker, Jayne Mansfield, and Grace Jones. I also have sacred and precious items that help me to remember my travels, loved ones, and important experiences. A Lucite Venus statue I found at an estate sale has a special place at my altar.

A vanity altar is not limited to a piece of furniture in a room. It can be your bathroom or any area of your home you spend the most time pampering yourself. One of my friends has a large mirror placed on her living room floor where she dances for hours and does her hair and makeup. We jokingly call it her witch mirror because anyone that comes over says it makes them look better instantly.

We are made to believe vanity is a vice but it is not. Mirrors and vanity tables hold a lot of energy. Your vanity altar is a special piece of you; it is an altar devoted to you. Think of it as a place for devotion and appreciation: devotion to beauty, appreciation for the little things that make life pleasurable.

Our vanity tables and counters are symbolic of the changes we have made as people. Colors of makeup, old perfume oils, and things we thought smelled good five years ago. Let this altar be an indicator of your personal growth and healing. Don't be afraid to cleanse and toss out any old items that no longer need to be there. Your altar should be a reflection of your ever-changing taste and dreams.

- Display your perfumes or fragrances on a beautiful tray to keep them from being cluttered.
- Add a vase with your favorite flowers.
- Include photographs of yourself and your style/beauty icons.
- Make room for your favorite jewelry so you can admire its beauty.

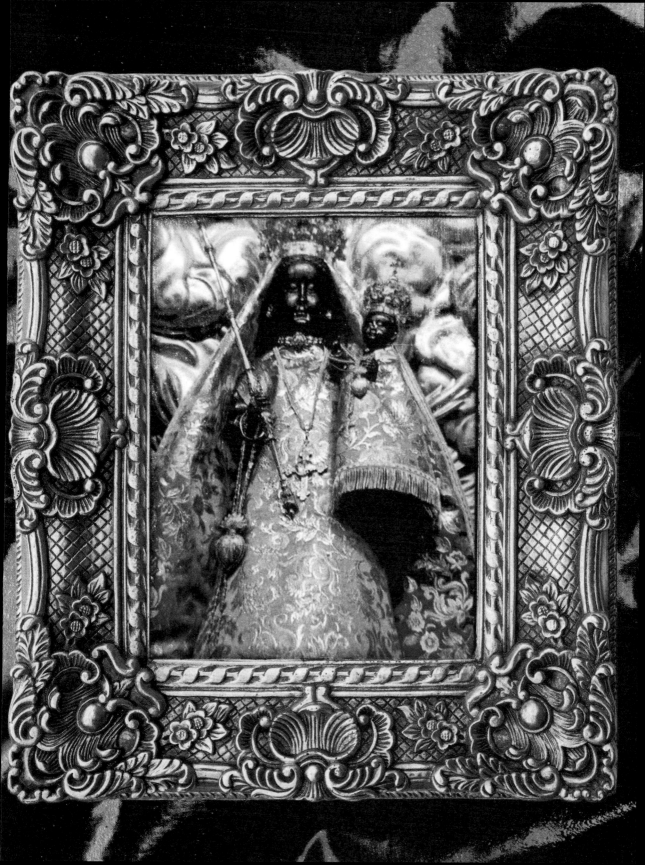

The sea has always soothed me.
I escape the chaos of the world by
sitting or sleeping for hours at
the beach.

When I was young, I would ditch
school to catch the bus to Venice Beach
just to lie out on the sand. I didn't
need a blanket or towel.

I would lie down, close my eyes, and
listen to the sound of the waves crashing
over my entire body.

And in that stillness, I heard La Sirene,
Yemaya, Mami Wata: Let me cleanse
you, mya; let me heal you, daughter.
She whispers to me.

I oblige.
La Sirene.
I cry with the sea, and she holds
me in her primordial depths.

Salt & sea.
A powerful ritual.
It never requires much.
Just softness.
Open.
Let her in.
Blood + Saltwater.
Seafoam and pearls.
Return to her mysteries.

THE SEA

I have shocked many friends by walking straight into the tides of a fully illuminated ocean on a full moon night, fully clothed or totally nude.

I am not afraid of her power.

Calm and soothing or vicious and unwavering.

I have laughed and cried with the ocean's tides. The same salt in those waves is in the tears that purify me. The sea is her own captivating spell that nourishes us and reminds us that from the mysterious watery depths we came, and to the sea we will someday return.

The human brain is receptive to the sounds of the ocean tides and the wave patterns have calming effects on our human psyches. Listening to the waves activates the parasympathetic nervous system, which makes us more relaxed. Staring at the ocean changes our frequency and puts us into a meditative state. Negative ions in the sea breeze have a mood-boosting effect.

When ocean water is used in spells it makes for powerful healing to restore emotional balance and to awaken the energy of a stagnant room. Collecting ocean water during a rainy thunderstorm makes for a powerful and potent cleansing agent. No elaborate words or items are necessary. Just a willingness to listen and to release. If you take from the ocean be sure to leave a small offering at the ocean's edge, something as simple as a strand of hair.

No matter where in the world I am, my body longs for water. Natural sources of water are ideal, but if I have to settle, I prioritize spiritual baths and cleansing.

Submerging. Floating. Releasing.

Ocean water uses:

1. Purification bath, for balancing and soothing anger and recalibrating emotions.

2. Blue and white candles.

3. Room spray. Use ocean water as the base of your spray. This is wonderful for energy— refreshing, especially in stagnant spaces of the home.

Ocean water alternative:

1 cup of water with
¼ cup Dead Sea salt

OBSIDIAN MEDITATION

Black obsidian is a wonderful and healthy way for people to break through emotional blockages and barriers in their sex life. It helps to release resentment and fear, and to remove negative attachments. But be warned: If you are afraid of the truth, this is not the stone for you. Obsidian releases negative energy held within the pelvis. It can bring up uncomfortable, sometimes repressed, memories from our subconscious. If you are ready to do the necessary work, obsidian is a helpful tool for clearing out heavy traumas, but it cannot act alone.

When I first started working with obsidian, I would wrap it up and keep it in the closet—that is how powerful and honest obsidian is. Black obsidian displays many faces (or forms) that constantly show us the presence of light within darkness. Over time and after being initiated into working with obsidian, I became more confident and comfortable with the stone. Today, I sleep with a massive obsidian sphere next to my bed.

Obsidian is formed as the result of a volcanic lava flow that has dried very quickly. In Mexico, its power has been valued by healers for generations. It is used to aid in repelling discordant vibrations, as obsidian can amplify and transmit an extremely high frequency, and to assist in the direction and maintenance of survival drives. However, obsidian goes beyond simply being a facilitator of basal directives; it helps us understand that within darkness, defeat, despair, and depression, the light of higher consciousness and hope awaits discovery.

Obsidian is very popular and can be found in a variety of forms: tumbled, polished eggs, spheres, pyramids, obelisks, pendants, necklaces, and so on. It can be fashioned into beads to keep around your waist for protection and grounding. Fortunately, most forms of obsidian are affordable, with the exception of larger sizes of rainbow or sheen obsidian. Snowflake obsidian and Apache tears are two popular varieties that are important

tools. Both are good for psychic protection, though black obsidian and Apache tears are thought to be more efficient in this area. Black mirrors made of obsidian can be used for gazing into other realms.

To prepare for your meditation, select a variety of obsidian stone that draws your attention. The shape of the obsidian you choose is also a matter of personal preference, but spheres and eggs seem to be the most popular meditation shapes. After cleansing and blessing your stone, as well as the space where you will be practicing your meditation, you are ready to begin.

Begin your meditation by sitting in an upright position with both feet flat on the floor. The room should be dimly lit and quiet. Make sure you are relaxed before you begin.

Begin to visualize golden or white light surrounding you and entering through your nose, filling your chest and heart center with warm, loving sensations. As you exhale, visualize frustration, resentment, anxiety, and anger leaving your body in dark, cloudy swirls. Bless this discordant energy in the name of the higher or divine power you feel most comfortable with.

Pick up the obsidian in your left hand and begin to gaze upon it. Notice the depth of its color: the rich, dark, satiny luster of your black crystal. Now repeat, "Attune, balance, integrate, ground," three times, then place your right index finger on the obsidian and begin to stroke it gently. "Attune to the depths of obsidian. Attune to the depths of the black ray."

After a time you might experience some warmth or tingling, especially along the spinal column, from your crown to your base chakra (muladhara),

Attune, balance, integrate, ground.

down your legs, and into your feet. This is the effect of your energy system attuning to the vibrations being amplified through the obsidian; it should not cause alarm. Relax, breathe deep, and allow yourself to merge with and absorb the energies transmitted by your obsidian crystal.

Envision the black color of obsidian at your base chakra. Imagine your base chakra as a liquid pool of black obsidian pulsating with the black energy that grounds you through your base chakra to the very consciousness of earthly existence. If you're using a rainbow or sheen obsidian, visualize the shimmering colors in your obsidian as swirling light vibrations above your head. Now allow those swirling lights to slowly travel the length of your crown chakra (sahasrara) down into the liquid pool of obsidian at your base.

Hold this visualization for up to ten minutes. Allow your obsidian to illuminate those aspects of yourself and your earthly reality that you have been keeping hidden. Allow the light of truth to illuminate the chambers where delusion, self-importance, and greed lie veiled by the ego-facilitated conditioned attitudes that may be keeping you from your highest potential. Allow your obsidian to assist you in seeing the reality of your thought patterns as they pertain to your survival on earth. Allow the light of truth to penetrate and illuminate the depths of darkness, and know that light and darkness exist as one.

When you are ready to end the meditation, slowly count backward from ten to one. When you reach one, open your eyes and breathe deeply several times. Remain seated and reflect upon your meditation experience until you feel fully integrated. This is an excellent meditation for journal writing.

HEX THAT BITCH

A hex is a form of magic meant to be destructive. It is an intentional use of destructive energy for revenge, retaliation, or vengeance, and is meant to cause harm.

If you've ever watched *The Craft* (of course you have), then you are aware of the infamous scene in which the Black teenager Rochelle is the victim of racism by her white classmate, Laura Lizzie. Fast-forward to the later scenes of this movie, when Rochelle casts a spell on Laura Lizzie to make all of her hair fall out. It works, and the filmmakers cut to a scene of Laura crying. The audience is meant to feel sorry for her and to view Rochelle's spell as bad.

However, was Rochelle's spell really a hex, as the film's creators would like us to believe? Or was this just divine retribution? An evening of the scales?

Where do we begin? For starters, being the recipient of the negativity you give out to the world—especially when it is racist—isn't a bad thing. Think about it: those who are racists, tormentors, rapists, and horrible people to the core deserve to receive what they put out. Not just times three or ten—but one hundred. Sometimes, individuals deserve everything that comes to them.

Man's enemies are not demons,
but human beings like himself.

—Lao Tzu

When is defensive magic a hex, and when is it merely a preservation of personal power? This is a dilemma that so many witches face. We are told that protection against the evils of our world, such as racism and sexism, are low vibrational and should be returned with kindness, good vibes, and turning the other cheek, but we are witches, not saints. There is no room in our culture for spiritually bypassing issues that affect marginalized people. I firmly believe that opposing forces that seek to destroy you merely for being born Black should be met with fierce protective magic.

If Rochelle had been surrounded by a coven of Black witches, she would've been the ultimate badass—more prolific and profound than her white counterparts.

Which brings me to *American Horror Story: Coven*. Angela Bassett was cast to play the infamous voodoo priestess Marie Laveau.

The show contrasts Marie Laveau, who was a pillar for Black people living in New Orleans, with Marie Delphine LaLaurie (portrayed by Kathy Bates), a slave owner who brutally tortured and killed her Black servants. The decision to juxtapose the two women made me furious. LaLaurie was a murderer whose crimes against humanity and society were abhorrent, while Laveau brought her community together.

For Laveau to be compared to LaLaurie is reductive, insulting, and frankly horrible. One is trying to elevate her people and the other is using brutal acts to bring people down. This show perpetuated the myth that a Black woman with magic abilities or any power is evil.

Fairness comes at a cost. Payback is a bitch.

NEW ORLEANS

New Orleans is powerful and sacred, and it is absolutely true that the spirits of the dead walk among the living there just as easily as you and I. The energy of New Orleans is *electric*, but do not take this lightly: the land and its inhabitants know how to pay their respects, and the dead certainly know how to party.

I went to New Orleans on a whim, after I had spent Halloween week working in New York City. My friend said she and a few others would be going down to New Orleans to celebrate Fèt Gede, and she asked me if I would like to come along. I had never been to New Orleans, let alone been invited to a voodoo ceremony, and I figured this would be a great time for me to connect with my family's roots, to see the birthplace of some of my ancestors' magic, and to take in as much of the culture as I could in the little time I had.

When I arrived at Louis Armstrong Airport, it was already well into the night. I was sent a text by my friend that instructed me to cover my hair with a black or purple head cloth and to dress in all white or purple and black. I was given the address where the ceremony would take place for the evening. I was hung over from Halloween and completely exhausted from traveling all day. I didn't have time to check into my hotel room, so when I arrived at the venue, I came with all of my luggage in tow.

I was met by a voodoo priestess's assistant. He was kind and welcomed me into the priestess's home. They were still setting things up for the evening, and there were beautiful altars filled with glass prayer candles all around. I wasn't really sure what to expect for the evening, but the energy in the space was already lively and intense. I came with an open heart and mind.

Fèt Gede is a celebration, but those who attend hope to gain a connection with their spirits. There are many gifts, including food, flowers, and libations given and offered freely, and there is an expectation that the spirits will reciprocate by protecting you throughout the year. This recip-

rocal exchange is of great importance: **Do not ask for anything that you are not also willing to give.** The spirits do not work for you as common servants—this is disrespectful and perhaps one of the rudest things any practitioner can do. What many people fail to realize is that your relationship with spirits should always be reciprocal. Imagine having a deadbeat friend or family member constantly asking for money and food but not appreciating the work or energy you put into making great things happen for them. By giving offerings at the feast, you express your gratitude. When you help the spirits out, they will be more willing to hear you and want to help you in return. Understanding this dynamic between you and your ancestral guides, regardless of culture, is good spiritual form. To bring gifts shows your respect and appreciation for the work they are doing for you, especially after making such a long journey between worlds.

I knew that experiencing Fèt Gede would be an important moment for me. Living in Los Angeles, I had never had an opportunity to learn from elders initiated into the religion and to gain a better understanding of my ancestors with firsthand experience. What better time than the celebration honoring the sacred dead?

I won't lie: I was nervous as hell. I had not been initiated into the religion, and I wanted to be as respectful as possible. I was a silent observer. While, yes, my family has roots in Louisiana, that did not mean I knew anything about voodoo other than what I'd seen in books and documentaries. I felt it was important to know my role and to understand that I was a guest in this ceremony. I made sure to cover my head with a beautiful purple satin scarf, as I was instructed to do, and to bring an offering. It's no different than visiting anyone's home when they are having a party. You are a *guest*—respect their home and bring a gift to show your gratitude.

When the ceremony began, there was an opening that included songs and offerings. The mambo created beautiful and elaborate *veves* (tracings),

and the drummers who had flown in from Haiti began playing. The intensity of the drumming did not pick up until much later, as the respected gede and lwa were being called in using complex drumming patterns. I was told that the closer you stand to the drums, the more likely it is that you would be mounted by the lwa, in what is called spirit possession. I was nervous and unsure if I was ready for all that, so I respectfully moved to the back of the room, where I silently observed the chants, singing, dancing, and opening.

After that, I felt and saw the most electrifying energy in the room. The air became heavier, hot—or was I just trippin' from the mugginess of the New Orleans humidity? Either way, I couldn't tell you, but as that drumming started speeding up, the energy build-up in the room too sped up.

Time was suspended.

We were now officially between worlds. I felt as if I were floating in a dream world. My body slowly began to rock back and forth, almost as if it were involuntarily happening. My bare feet began to tingle.

Electric sparks were bursting through that entire room.

Energy and heat building, building, building.

I watched as people drank from a large clear bottle of alcohol that had been prepared especially for the ceremony. It consisted of multiple types of *very* spicy hot chili peppers along with other potent botanicals soaked in alcohol. I was told that if you were not taken over by possession and were to try to drink this alcohol, it could burn a hole clear through your tongue.

An older gentleman wearing a top hat and black sunglasses with one lens removed, much like the image we see of Papa Gede, took a big drink

straight out of the bottle of this liquor, then I watched as he spat it into the humid air. You could feel the heat from the liquor as it sprayed into the atmosphere. It burned and tingled my eyes and skin. There was a cloud of sweat and shouting and dancing, and from that point forward my mind went blank.

I cannot tell much else of what happened, out of respect for the ancestors and gede that were present, but I will say that this experience changed my life. It changed my perceptions on magic, life, death, and the cycles of rebirth. It challenged me and humbled me to my core. I am honored to have been a witness to this ritual at the time in my life when I most needed this energy. I believe this was the only way to be welcomed into New Orleans for my first trip. I left with a much deeper appreciation for what

my ancestors and many African people did to maintain the culture in secret in the community, keeping these traditions alive so that I might be able to witness and partake in ceremony just as they did. I was given a glimpse into the traditions of African spirituality, and for that I am grateful.

New Orleans energy is like no other place on earth. If you are sensitive you will hear and feel the stories that it tells loud and clear. Eat, drink, and be merry, but don't forget to pay your dues with a humble heart and plenty of offerings to those who have come before you. There is mystery and real potent magic to be found there if you know where to look. **Come correct, or don't come at all.**

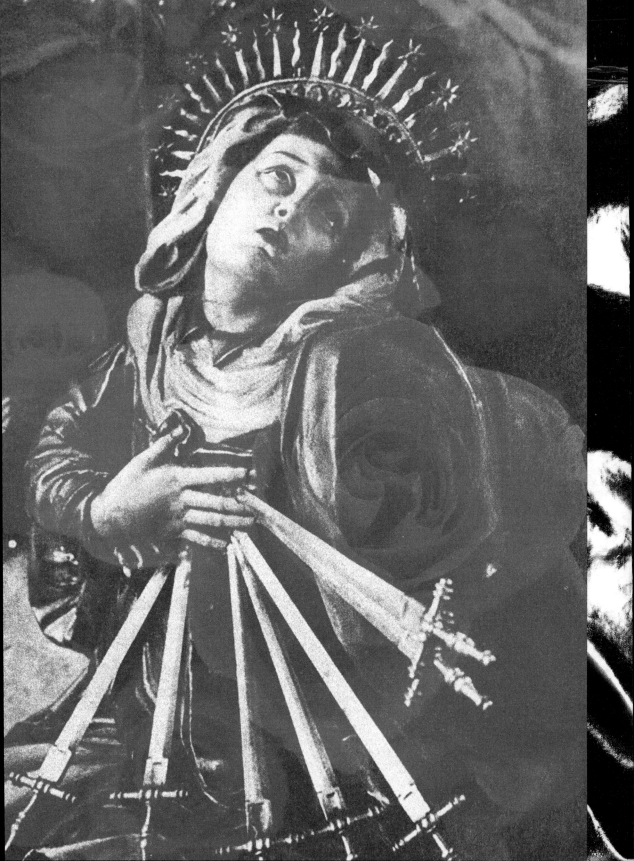

WITCHIN' WITH ANXIETY

Chill, it's only chaos.

In intense times, it's important to decompress—especially if you are energetically sensitive and pick up on other people's anxieties or the energies of the collective.

Release + Repeat: A Practice

AFFIRM: All that is not my energy, drop away from me now. All that is my energy baggage [energy that no longer defines who I am or who I am becoming], drop away from me now. Flood my being with the divine rays from Source to fill me and my multiple bodies: physical, emotional, mental, and spiritual.

And so it is!

MEDITATE: All of this is easier said than done, but these actions have been helpful for me. Sit or lie in silence. You're not doing it wrong, even if it doesn't feel right. Take some time to relax, consciously letting go of any tension. As thoughts arise, let them go. Don't anticipate anything—just sit in silence. The experience of this simple meditation is very different for each individual. Sometimes there are instant insights, and difficult problems dissolve into simple solutions. And sometimes we can't stop thinking about the million things we have to do and, therefore, can't find silence. Being able to meditate is a skill that takes practice and dedication. Yes, we all know we need to meditate or take social media breaks, but realistically, it is increasingly difficult and directly affects our ability to be intentional. A witch must work with intention. You cannot build intention without the ability to clear your mind. If you've never tried silent meditation, it might feel like nothing is happening at all . . . but then days, weeks, or months later you realize the value that you have gained.

We absolutely *must* take care of ourselves. Do whatever healing you need to do today to clear your mind and ground your energy.

Just breathe. Inhale and exhale slowly, evenly, and deeply for several breaths.

Unplug from media. The news, television, and scrolling social media can be too stimulating, and overstimulation can worsen anxiety.

If you can't escape your office, school, or stressful setting, try downloading a soothing app or using guided meditations and calming music to help you recenter.

Acknowledge your feelings (verbally or silently). Talking with a trusted friend or therapist, or writing in a private journal are the best ways to channel intrusive or overwhelming thoughts and feelings in that exact moment.

Remember, your feelings are yours and yours alone. They don't need justification, nor do they have to make sense to anyone but you. Don't be ashamed of feeling overwhelmed.

No one will believe like you.
No one will practice like you.
Your magic is a personal journey.
No one else is living it but you.

White Spell Bath for Purification
CÁLMATE: BAÑO BLANCO (CALM: WHITE BATH)

What are baños blancos? White baths are specifically formulated to cool the head (ori) to improve mood and behavior. Cleansing with cool water has deep roots in the Yoruba traditions of bathing and cleansing in fresh river waters to calm down any fiery or hot energies that evoke anger or anxiety, and to restore balance, tranquility, and peacefulness to our overall well-being.

This is a beautiful white bath designed to help purify and cleanse the body of negative energy in your aura. It helps promote peace and tranquility. This bath also helps you have a restful night's sleep. It is safe for children, and can be used for babies and toddlers as well.

YOU WILL NEED:

Carton of goat milk

Warm melted coconut butter or bottle of natural coconut water

½ gallon cow milk

Holy water

Cascarilla

White carnation flower petals (or any white flower petals will do)

White towel

DIRECTIONS:

Pour the goat milk and coconut butter into the cow milk.

Add a splash of holy water.

Sprinkle in the cascarilla and the white flower petals.

HOW TO USE:

Pour some baño blanco into a bowl and set aside.

After showering, rinse yourself with the white bath from head to toe, then rinse it off.

Dry yourself with a white towel.

Take this bath for at least three days in a row to feel the effects. Divination will help determine how many days are necessary.

It is important that you go to sleep dressed in white or sleep on white bed linens.

Take this bath when you have time to fully relax. If you do not have a bathtub, you can prepare this in a large bucket or bowl and pour over the head and body. Rinse in the shower so that you will not be sticky.

You should feel the effects immediately.

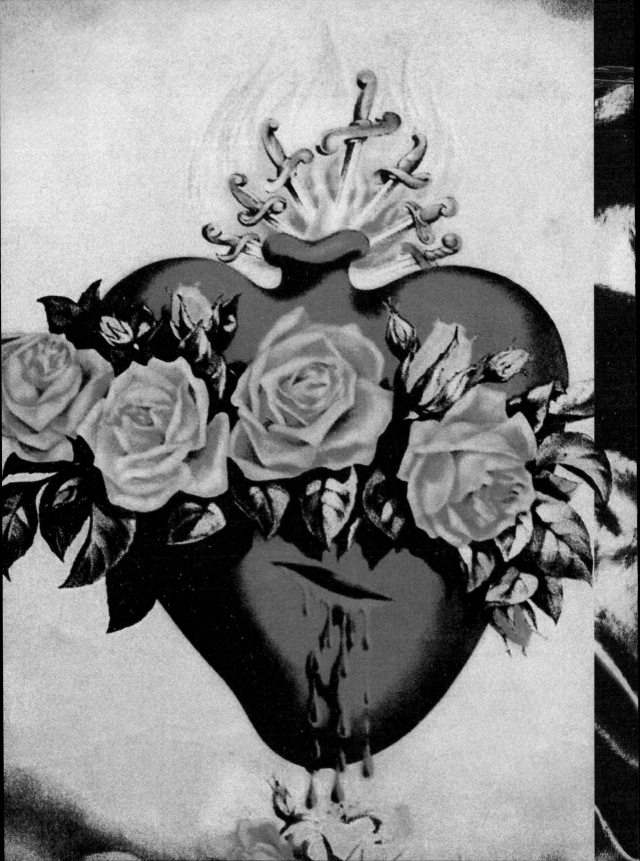

GREEN JUICE AND WHISKEY

As a tween I really loved browsing a catalog called the Pyramid Collection that my teenage cousin Ricci received in the mail. The catalog featured a variety of crystals, amulets, and really cheesy "pagan" paraphernalia for the newbie baby witch, and of course your everyday Anne Rice–style '90s vampire attire. Looking back now I feel like the imagery from this catalog really shaped me. I loved it, and I feel that browsing this catalog definitely influenced me to be the weirdo I am today. I remember that this catalog also featured books, tarot decks, and ancient Egyptian knickknacks. As a child and teen, I was always drawn to the unknown, to ghost stories and the unexplainable. My cousins received the Pyramid Collection catalog and also had a collection of books titled *Mysteries of the Unknown*, which you can still find in most thrift stores. These books were all about UFO sightings, ghosts, séances, tarot, and stories like Atlantis in serial form. I would spend *hours* browsing their books, as my cousin played Nine Inch Nails and obsessed over taping Marilyn Manson posters to the walls. I thought she was the coolest witch in our family—after all, she was the first to wear Wet n Wild black lipstick and nail polish that screamed "cool witch."

Magic in my family didn't look like that. In fact it didn't really look like anything outside of my grandmama's candles and oddly placed glasses of water above doorways. That's always been the beauty of magic and witchcraft: it doesn't need to look like anything other than what is authentically you.

The beauty of magic and a witch's work is that there is no one size that fits all. What you might consider dark and evil someone else might consider cathartic and affirming. As I began navigating spiritual practices and spaces outside of what was familiar to me, I didn't feel that I belonged. What little representation witches had in pop culture at that time always seemed to focus on European traditions. That was a driving force for me

to start the Hoodwitch. I embrace my Mexican and Black culture through fashion and contemporary art. I acknowledge all parts of myself without having to be neatly packaged into what people think spirituality is supposed to look like. I like to say, "I am green juice and whiskey," and laugh at myself. I am darkness and light; I embrace duality.

I break away from all conventions that do not lead to my earthly success and happiness.

—Anton Szandor LaVey, *The Satanic Bible*

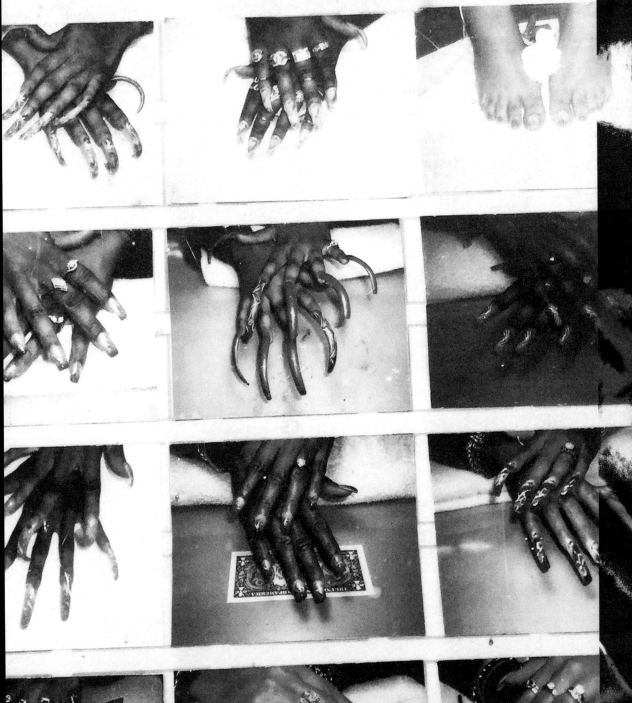

ALTAR OF NAILS

One of my fondest memories as a little girl was spending time with Grandmama Althea in the small chemical-fume-filled nail shops of Los Angeles. My grandmama and mom loved going to Mantrap Nails, and I was enamored with the elaborate airbrush nail designs displayed among rows of colorful nail lacquer bottles. When I close my eyes, I can still see the large '90s wall art displaying a woman with perfectly manicured hands showcasing Million Dollar Red nail polish as she held a wad of cash or a single red rose.

You always knew who was the most skilled manicurist in a salon because they usually had a line of regulars that got priority over any newcomers. Back then, the most requested technicians would have a large photo album on their table that featured hundreds of anonymous Black and Brown hands captured on 35mm film exhibiting the elaborate nail designs of clients and regulars. We would skim these photo books to gain artistic inspiration for the design art we wanted for our nail sets. It was also a great way to spend time while you waited for your appointment. This process could take hours, depending on how popular your nail technician was, especially on a busy day or a weekend. If the nail shop was a temple, then that photo book would certainly be a sacred book that embodied the heart and soul of the nail shop; it was the documented history of a special kind of magic that took place there. I would sit patiently, swinging my legs under the light of a glowing neon pink sign that read "NAILS" next to a dusty old Patrick Nagel print hung with thumbtacks.

Being the curious child that I was, I noticed and loved the small altars created by the Vietnamese nail technicians. Each altar, discreetly placed in a corner of the nail salon, showcased electric candle lights and offerings of incense, coffee, and bowls of fresh fruit, usually oranges and apples. I learned that these were ancestral altars used for honoring family members who had passed on. Tam Giáo (the three teachings) is essential in

Vietnamese culture. It is a combination of Mahayana Buddhism, Confucianism, and Taoism, and every nail shop I have ever been to has an altar.

Tweety, whose real name was Tran, was one of my favorite nail technicians. I went to Tweety for manicures and pedicures for most of my teens and throughout my twenties. I adored her creativity and her enthusiasm about trying wild new designs that reflected my mood. During that time, Tweety explained to me a lot about Vietnamese culture, especially when I asked her about the significance of the altars. She told me that it was important for them to perform rituals for their ancestors, because if they didn't, it would cause their ancestors to become angry hungry ghosts. A hungry ghost is believed to cause all kinds of misfortune and bad luck for a business. It is important to keep your ancestors' spirits soothed and content through acknowledgment, respect, and offerings. Tweety explained to me that the nail technicians all had altars to honor their ancestors in their homes too. The afterlife is something Vietnamese people take seriously and pay great reverence to. The altar is placed in the home and business with photos, fresh fruit, traditional Vietnamese foods, and other gifts, such as incense that is burned daily.

I loved learning about Tweety's culture and ancestral rituals, and I loved my matriarchal beauty rituals in the nail shop. The special bond uniting my grandmama, my mother, and myself on the days when all three of us scheduled together was strengthened by laughing, gossiping, and enjoying each other's company.

My grandmama wore the same nail polish color for over twenty-five years—she never deviated from the hot fuchsia appropriately named Tiki Punch. The color was manufactured by a popular and affordable nail polish brand called Sation, which also made the color Cotton Candy, a hood classic. This shade was an ethereal opalescent that had pinks, blues, and soft lavenders and would become one of their best sellers. It still holds

much nostalgia for Black and Brown women of '90s nail shop culture. You could have gold charms in the shape of your loved one's initials, hearts, or Playboy bunny logos added to your nails. If you really wanted to show off, you could be lucky enough to get a money manicure—yes, that's right, real money would be cut up and placed on the acrylic tips and sealed onto the nail. This manicure was originally created by a Black manicurist, Bernadette Thompson of Yonkers, New York. She created the flashy and innovative design on a whim for the rapper and cultural icon Lil' Kim. Bernadette's visionary manicure would spark a craze that spread throughout hood nail shops across the United States for every fly girl who wanted to flaunt her style and status. Bernadette used real hundred-dollar bills when she created the look in 1997, meticulously placing cut-out bank notes on Kim's French-tipped nails for a photo shoot shortly after her hit song "All about the Benjamins" was released. The trend became so popular that Thompson received a formal letter from the US Treasury Department warning her that defacing or destroying US currency was illegal, and she could be fined or face jail time if she continued. This didn't stop the artist or any of the nail techs across the country that jumped on the decadent and costly trend. Bernadette says in order to avoid legal consequences she later in her career advised her clients to bring their own precut bills. These days most nail technicians use fake money specifically for re-creating the luxury nail set without breaking the bank. In 2017, Lil' Kim and Bernadette's infamous money nails were displayed in New York City's Museum of Modern Art for the exhibit *Items: Is Fashion Modern?*

Grandmama wore her nails long, curved, and with three tiny rhinestones on the tips of at least two fingers on each hand. I loved the way her Tiki Punch nail polish brought out the richness of her deep chocolate skin and the way she wore ornate fourteen-karat gold rings displayed proudly on each of her long fingers. Grandmama never let me get my nails polished

Showing up as your
will always be the

most authentic self
most powerful spell.

A manicure is not super expensive.
It's less than an Hermès bag.
And you wear it every day.

—Bernadette Thompson

in red. She would lean over and softly whisper, "Little ladies don't wear red nails." Grandmama was firm on this rule, and I knew not to ask when we stepped foot in the salon with her. Back then, I didn't understand her hang-up with me having red nails, but I for damn sure wasn't about to question her.

Red nail polish certainly has a rich history, dating as far back as the Egyptians, who believed that dark nail colors were to be strictly reserved for the elite. Nefertiti and Cleopatra were two women known for their love of adornment, and that included red nails. Red nail polish was seen as a sign of wealth, power, and status. The ancients of civilizations from Sumeria to China used crushed red ochre and henna powder as the earliest forms of nail dying. During the Ming Dynasty in China (600 BC–1644 AD), long artificial nail extensions painted bright red were worn to indicate status, showing that the individuals who wore them were above manual labor, a clear distinction for noblewomen of this time. It wouldn't be until much later that red nails became associated with women of the night. In the 1950s, wearing red nails was considered promiscuous—leave it to the church to require that women remove their nail polish on Sundays before service. This is yet another patriarchal stigma that can be traced to the prudish Victorian era, when it was considered exceptionally sinful to paint your nails, and the women who did were typically sex workers. Throughout history, red has been associated with adultery. As far back as the 1850s, the famous book *The Scarlet Letter*, set in a New England Puritan community, depicted a woman being punished for adultery who was met with cruel ostracism. Her sin was represented by a red *A* sewn onto her clothing. Society should have moved leaps and bounds since the days of *The Scarlet Letter*, but have we really? Red is still commonly associated with

prostitution. Sex workers throughout the world have been required to wear red to announce their profession, and houses of prostitution were made to display a red light outside the premises. Beginning in the early twentieth century, houses of prostitution, or "cat houses," were allowed only in specific neighborhoods. These were usually poor communities with elevated levels of crime, which then became known as "red-light districts."

The persecution and stifling of women and their bodily autonomy is nothing new; to this day it is an ongoing struggle that we continuously face. As a woman of color in a world that wants you to shrink and compromise yourself, to conform and become more easily digestible, I say fuck that—reject any and all boxes that are made to keep you small. Be bold, unapologetic, and extra. Black and Latina women have historically had to conform to society's standards of beauty, whether in changing our natural hair texture or shortening our nails or toning down our clothing and accessories for respectability or professionalism. One woman who has always stood out to me in the world of nail art was Florence "Flo-Jo" Griffith Joyner. Joyner was a track star who became a legend at the 1988 Olympics when she set still-standing world records in her races. Flo-Jo refused to compromise her style, especially her very flashy long nails and the full makeup she wore to each meet. Most people don't know that Flo-Jo worked part-time in a nail salon as she prepared for the 1988 Olympic Games. She made history and became the first Black woman to win four medals at a single game. Flo-Jo gave herself an elaborate and intentional set of red, white, and blue nails to represent Team USA and painted two of her nails gold to symbolize her intent to win the gold. Flo-Jo left the Seoul games with three gold medals and one silver: manifestation and glamour magic at its finest.

Showing up as your most authentic self will always be the most powerful spell.

* * *

When I began creating visual content for the Hoodwitch, it was very important for me to showcase my culture in my art, so I began shooting photos of my hands with fresh manicures clutching a variety of my favorite healing crystals. I wanted to create a space that felt relatable, informative, and truly representative of me. This was my way of creating authentic and meaningful imagery to captivate my readers. During this time, I really felt othered. No one else was doing what I was, especially not in the form of art in the witch community. My long acrylic stiletto nails became my signature look and eventually became synonymous with my brand. I was blown away when I was asked to be featured in *Vogue* magazine. My first interview for *Vogue* was written by a brilliant Black journalist named Marjon Carlos. She found my work through social media and reached out to me for a feature. I was a bit hesitant at first to have my photo in *Vogue*, but I realized how important this was for my community and for the brujas I represented. Representation matters, and the work I was doing by merging beauty and spirituality in such a huge publication really meant a lot to me. I knew little baby witch Bri would have been proud to see an article like mine when she visited the nail shop with Mom and Grandmama back then.

What was once dismissed as simply being "ghetto" or "tacky" has become a more popular and well-received art form. By no means am I making a claim for popularizing nail art—quite the contrary. I respect and honor every strong femme who has come before me in popularizing beauty and glamour as essential components of a fulfilling magical self-care practice. I did it my way in a community that once dismissed beauty rituals as being nothing more than shallow, unimportant acts of vanity. I'm here to say that simply isn't so. **Anything that heightens your confidence and makes you feel more beautiful in your own skin is powerful magic.** Let the children of Venus, Oshun, and Xōchiquetzal shine like the stars they were meant to be.

You don't ever have to give up your authenticity to fit in or be part of the status quo. You can be successful in spaces that don't understand your aesthetic or the meaning of your beauty practices. What matters is *you*—anything you do to empower and heal yourself, regardless of how inconsequential it may seem to the outside world, let this become *your* personal beauty ritual. Only you can define your magic.

I still to this day smile deviously whenever I catch a glimpse of nails painted in the reddest of "ho reds," because they're sexy as hell, classic, and powerful. Sorry, Grandmama, your grandbaby is a Lilith, not an Eve.

COLOR MAGIC

Color magic is the art of knowing each color's unique properties and using them to assist you: be that in candle magic or glamour magic. Learning the basics of color magic will help improve the correspondence of any energetic work you do.

Red: passion, lust, attraction, stamina, courage, sexual energy

Pink: flirty, self-love, heart healing, romance

Orange: success, ambition, joy

Yellow: confidence, happiness

Green: abundance, money, prosperity

Blue: focus, mental peace, soothing

Violet: intuition enhancing, creativity

Black: psychic protection, grounding, courage

White: calmness, protection, healing

Gold: solar energy, abundance, money, prosperity

Brown: grounding, stability, warmth

Silver: lunar energy, visions, intuition

MAGNETISM RITUALS

With magnetism and beauty rituals we attempt to draw people to us. There are bath spells, mirroring spells, candle spells, oil beauty spells, and makeup as transformation. This is about the physical—it is about self-confidence and even vanity. Work with what you have.

Transformation is a part of magic. However, any source of magic starts with how we feel. We are the creators of the energy we put into the world. When the energy outside is ugly and negative, a beauty ritual can be an exercise of control, safety, and preservation.

Personal magnetism is about attracting and charming. Some people naturally have this quality about them, but it is a quality that can be created too. Personal magnetism rituals are great for a new job or a first date, when you want to put attracting energy out there.

Cleanse. Start your beauty ritual with a clean slate. Just as in any magical work, you will need to cleanse your body and yourself. Play your favorite music, light candles, and make sure your brushes and tools are cleansed. Burn your favorite scents, have a glass of wine or a relaxing cup of tea—whatever makes you feel relaxed.

Visualize. What is your mood? What energy would you like to channel? What archetype or energy would you like to embody to help you accomplish your goals for the day? Working with a divine being or archetype helps us when we need some confidence or protection, or if we simply want to take on a sexier persona.

Affirm. Self-love and self-acceptance go hand in hand. We are all conditioned to speak negative talk and pick ourselves apart. Now is the time for you to reclaim those parts of yourself and call back your power.

Mantras. They help us remember our divinity. What part of your body needs more love? Bless the things you like and dislike equally. I personally

like to sit naked in front of my mirror and affirm to myself, "I am strong," "I am beautiful," "I am fearless." You can create your own meaningful beauty mantra before applying your makeup, or simply sing the words to a powerful anthem.

Closing. Acceptance and integration will amplify your beauty ritual. Once your look is complete, end your ritual with gratitude, thanking your guides, the universe, a chosen deity, or your higher self. Now you are ready to face the world. Be bold, fearless, and confident no matter what.

May the cleaning flames of renewal ignite my soul's passion.

A HONEY JAR
FOR SELF-CONFIDENCE

Love magic and sweetening spells are often associated with the love of others, but how often do we take the time to give that same love, adoration, and sweetness to ourselves? We all have days when we struggle to see our own beauty. Sometimes we get so caught up in the beauty standards of our environment that we forget just how beautiful and amazing we are. Over time I have learned that my favorite spells and most potent love spells are the ones I've cast on myself.

Insecurity and a lack of self-esteem do not have some quick fix that can heal with just one jar spell, but it is a start. It takes a lot of time to unpack the deeper issues. This is a spell for those who want to cultivate a more powerful and deeper connection within themselves to feel beautiful inside and out.

Sometimes we get so caught up in the beauty standards of our environment that we forget just how beautiful and amazing we are.

Honey Jar Spell

YOU WILL NEED:

Incense

Paper

Pen

Small jar with a metallic lid
(I like using jars with metal lids
because you will be burning
candles on top.)

Anointing oils, like rose oil

Herbs, dried rose petals or
hibiscus flowers, vanilla, or
damian

Pink or red glitter

A photograph of you to be placed
inside the jar, or anything that
feels symbolic of self or beauty
for you

Good quality honey (This is an
extension of the self, so purchase
the finest natural honey you can
afford.)

Red, white, or pink candle

DIRECTIONS:

Create your petition:

Light incense, then take a few deep breaths
and set the tone.

Prepare your petition paper. This can be a
small piece of brown paper bag that is cut
into a square or a heart. Do not use anything
with jagged edges.

You will need your petition paper to be large
enough for your petition but also small
enough to fit inside the jar after it's been
folded.

For honey jar petitions, it is important that
your message be short and sweet. Write
something simple like "self-love,"
"acceptance," or "confidence."

Now that your petition is written, take your
desired oil and pray for what you want, then
anoint each corner of your petition plus the
center with the oil.

Adding herbs, roots, and other materials:

Since this honey jar is for self-love, you will
add materials that have powers pertaining to
love. What you add is up to you, but a few
suggestions are:

- Dried rosebuds or rose petals (do not use
 fresh roses or lavender as they will rot
 and make the jar stinky)

- Vanilla for love and passion
- Damiana to increase desire and enthusiasm

Place the herbs in the center of your petition paper. You only need a tiny pinch of each ingredient because you are making a small packet to go in the jar. Feel free to add colored glitter to magnify your spell. You can also include a photo or a lock of your hair.

Making the honey jar:

Fill your jar with honey. You don't need to fill to the brim, because you want room to be able to "work" the jar (shake it up).

Take your petition with all the ingredients on it and carefully fold it once toward you. Then turn it clockwise ninety degrees and again fold it toward you. Keep folding until you have a roughly square-shaped package with all the ingredients safely wrapped inside. Please note that you fold the paper toward you, as you are welcoming in love, not sending it away.

Next, take the jar and push the petition package into the honey with your finger while saying, "As this honey is sweet to me, I will be sweet to myself."

Lick the honey from your fingers and repeat the dunking process two more times, so that by the end you will have pushed the petition into the honey three times and will have said the words three times. After the third time, close the lid of the jar.

Light the candle and place on top of the jar. Let the wax run over and seal the jar (keep it in a safe place and keep an eye on it).

Honey jars aren't generally one-off spells. They are meant to be worked on a regular basis, whenever you are feeling down and in need of a boost in confidence.

Traditionally in hoodoo, a honey jar for love is to be worked every Monday, Wednesday, and Friday for as long as you want to keep the effects going.

Honey jars take time. Think of how honey flows from a jar, and be patient. The best advice I've ever been given for spell working is not to focus obsessively on the outcome.

Keep your honey jar on your night table or vanity. Spend time shaking the honey jar and asking it to wake you up and help you achieve your goals. This is an important step whenever you work with it and before you burn your next candle.

I am ancient and modern. I am nature and I am city. I am the essence of copal smoke floating in sunlight. I am a rainbow display case of novenas at the botánica. I am a

gold nameplate necklace and perfectly manicured acrylics clutching quartz crystals in the moonlight. Remain authentic to your vision and stay true to your own magic.

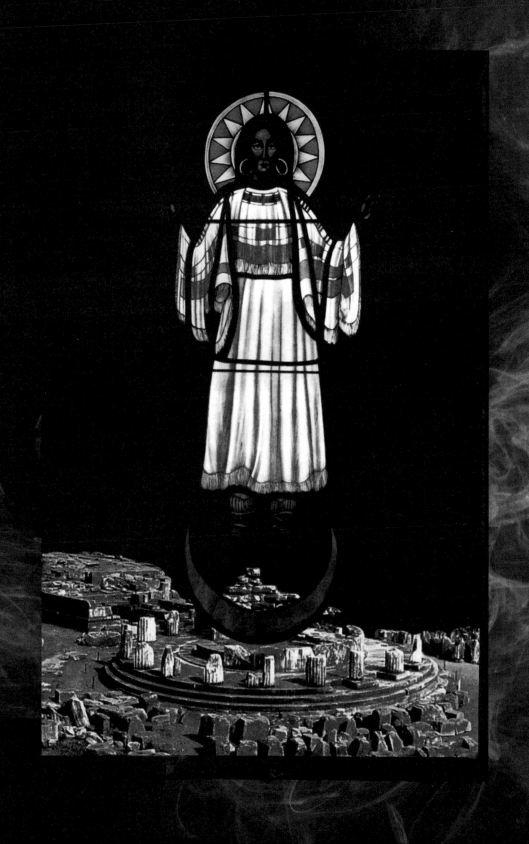

MAGIC IS YOUR BIRTHRIGHT

Magic is available to anyone who pays attention. Dancing under the full moon's light, swimming in an ocean, healing in the sun's rays, sitting in the silence of a forest, or taking your shoes off and grounding your energy in a park. Connecting to yourself and nature in this manner doesn't cost a thing.

Science says we are composed of the same materials as the stars above us, as well as the components in the soil and the trees below us, so are we not also as divine?

I believe we are all interconnected in this great web of life and that even the tiniest accomplishments matter. The more we evolve and transform, the more in tune we can be with ourselves, others, and the rhythms of the universe—which is the essence of magic.

The modern-day witch is adaptable. They are able to adopt ancient or passed-down skills and rituals, and adjust them to fit into their everyday life. No matter where you live, or your circumstances, you are able to cultivate magic in your environment. It's truly about adapting and evolving.

Women are reclaiming their personal power, and that scares some people. This power or energy has been inside of us for many, many years. It's ancient wisdom that has been suppressed due to societal conditioning, pressure to conform to what is deemed acceptable behavior, and yes, of course, religion. Many young women have been taught to ignore or discredit things like their intuition, or what some might even call their psychic senses, for fear of being ridiculed by friends and family members or called crazy or told they are doing something evil. People are seeking the information that these esoteric or occult practices provide.

A warning: don't join a cult. Spiritual leaders can too easily abuse their power, as often happens with authority figures.

Any so-called spiritual leader or guru who doesn't allow you to ask questions, preys on your vulnerability, and isolates you is not empowering you or teaching you anything except submission. Do what empowers you, with discernment.

This book is the culmination of ten years of the Hoodwitch and a lifetime of practice.

It is a celebration of the curanderas and the wise women in the neighborhood botánicas where I grew up. These wise women were the healers. They are beacons of light for their community, and that has always inspired me.

When all felt lost, I knew I could always return back to myself, my memories, and of course, to magic, and for that I am eternally grateful for the divine mystery of the universe, my ancestors, family, and friends, and the wild witches who have come before me and who continue to open the doors and clear the paths for me in realms both seen and unseen.

ACKNOWLEDGMENTS

This book saved my life. Researching and writing helped me solidify certain parts of my magic in ways I never thought possible. I was required to surrender fully to the unknown—to trust the cycles of life, death, and rebirth. I would like to thank: My ancestors and spiritual guides in realms both seen and unseen. Those who have paved the way for me and continuously shielded me in their love, fierce protection, and care. My grandmothers, Althea and Sylvia, whose love has transcended all realms and supported me throughout this process. My beautiful mother, Triana, and my dad, a.k.a. "Lonnie the King"; my son, Elliot; my sister, Trinel.

Thank you for the love and support from David Cook, Gabriella Barboza, Lisa Steinmetz, Michael Cardenas, Chenice Tallbas, Jewel Cruell, Ricci Olson, Anastasia Cruell, and Autumn Turner. Thank you to my extended family and way too many friends to name. Thank you to everyone on my publishing team at HarperOne. There are two people who made this book eminently more readable than it might otherwise have been: Sydney Rogers and Thomas Flannery. Without your guidance and endless pep talks, none of this would be possible. Ryan Amato and Gabriella Page-Fort, I appreciate you both so much for your patience, care, and organization through this process and for making this magic all come together!

For all the witches, bitches, brujas, healers, seers, and magic makers who've come before me and who will come after me. Thank you to all the Hoodwitch supporters from day one.

This book is dedicated to the creators and the destroyers.

CREDITS AND PERMISSIONS

Grateful acknowledgment is given to the following for the use of their photographs and illustrations in this publication:

Copyright © Africa Studio/Shutterstock: 196

Courtesy of Arely Catalina Ruiz (csfilmmedia.com): 18–19, 26–27, 40, 54, 57, 108, 144, 154

Copyright © ArtBackground/Shutterstock: v, 4–5, 70–71, 142–43

Courtesy of the author: ii–iv, 3, 11–12, 14–16, 20–21, 31–32, 41, 43, 46, 48, 63, 67, 83–86, 90, 92–98, 104, 111, 114–16, 119, 127, 134–35, 145, 147, 150, 159, 164, 172, 175, 178–80, 184–85, 189, 191, 196, 198, 205, 211

Courtesy of the author's family archive: 14–15, 32, 40, 42–43, 45, 50, 64, 68–69, 106

Copyright © BearFotos/Shutterstock: 32, 50

Courtesy of Brian Ziff: endpapers, i, 212

Copyright © Bruno_Doinel: 10

Courtesy of Cici Gomes (@moonsignmagic): 140–41

Copyright © cybermagician/Shutterstock: 117

Copyright © darkbird/stock.adobe.com: 98, 121, 125, 137–38, 163

Copyright © EKH-Pictures/stock.adobe.com: 128

Copyright © exopixel/Shutterstock: 48–49, 88

Courtesy of the Fowler Museum at UCLA: 156–57

Copyright © gillmar/Shutterstock: 40

Copyright © Groundback Atelier/Shutterstock: 7, 13, 39, 66, 72, 102, 106, 109, 113, 122, 161, 186, 197

Copyright © Heorhiy Sidun/Shutterstock: 28–29

Copyright © HHelene/Shutterstock: 64, 68–69

Copyright © Ines Behrens-Kunkel/Shutterstock: 116

Copyright © Jagoush/Shutterstock: vi, 127, 165

Copyright © Jossfoto/Shutterstock: 134–35

Copyright © KOTL/Shutterstock: 166

Copyright © LightField Studios/Shutterstock: 48–49, 63, 83, 92–93, 111, 116, 119, 175, 198–99, 202–3

Copyright © LiliGraphie/Shutterstock: 14–15, 18, 26, 35, 42, 45, 170–71

Copyright © Mrakor /stock.adobe.com: 150

Copyright © mrks_v /stock.adobe.com: 153

ABOUT
Bri Luna

Bri Luna is the founder of the Hoodwitch and is dedicated to empowering, educating, and cultivating community through meaningful rituals that support self-care and wellness. Luna is devoted to offering "Everyday Magic for the modern mystic" through her art and advocates for the use of traditional healing practices to address modern-day challenges. She and her work have been featured internationally and in major publications, including *Vogue*, *I-D*, *Playboy*, and the *New York Times*.